newcomers to neighbors

migrants and refugees from the Middle East
in Southern California

BIOLA UNIVERSITY | DEPARTMENT *of* MEDIA, JOURNALISM *&* PUBLIC RELATIONS

faculty advisors

Michael Longinow
Tamara Welter
Michael Kitada

cover photo

Brenna Khaw

book consultant

Rafael Polendo

———————————

© 2019 by Biola University
Department of Media, Journalism, and Public Relations

Published by Biola Avenue Press
Imprint of the Department of Media, Journalism, and Public Relations
13800 Biola University Drive, La Mirada, CA 90639

Printed in the United States of America

ISBN 978-0-9839572-3-2

Requests for information should be addressed to:
Dr. Tamara J. Welter, Chair
Department of Media, Journalism, and Public Relations Biola University
13800 Biola University Drive, La Mirada, CA 90639

**previous titles from
BIOLA AVENUE PRESS**

Mission of Hope (2009)

Skid Row: You Don't Come Down Here Without Change! (2010)

Dominican Dream: A Passion For Baseball, A Love For Family, And a Hope for the Future (2011)

Growing Up In East L.A. (2014)

Haitian Eyes, Haitian Hands (2015)

Beyond the Wall: Migrants, Migration and the Border (2017)

BIOLA AVENUE PRESS is an imprint of the Department of Media, Journalism and Public Relations at Biola University. The books it produces are part of an upper level course aimed at giving students practical experience with in-depth reporting, writing, photojournalism and graphics design aimed at guiding students in cross-cultural topics in the U.S. and in other countries.

introduction

by Michael Longinow, Ph.D, Tamara Welter, Ph.D, and Alicia Dewey, Ph.D.

We live in an era of fear. Some of it is well-founded: dangers on the roadways, threats of attack through our computers, risks to us from unscrupulous medical professionals, corporate power-brokers or politicians. But there is a fear few of us in Southern California know: it is fear of being blamed for fear. People whose families came from Middle Eastern countries — whether last Tuesday or in the last century — live with the sideways glances, the whispers, perhaps the outright comments of those who see them as dangerous. If they dare wear clothing that celebrates Islam or Coptic Orthodox Christianity they invite even more scrutiny, even violence. They feel the pressure most vividly in airports and in traffic stops. Their skin color, their hair color, their eye color comprise a kind of trigger for some Americans who tie them to that horrific Tuesday in September, 2001.

Media imagery has made the suffering worse. News journalism too often reverts to stereotypes to simplify (or oversimplify) storytelling about events involving people in Middle Eastern countries, or who live here with origins in the Middle East. Reasons for media misinformation about Middle Eastern people are many; chief among them is genuine lack of familiarity with the vast, diverse cultures, the unique histories, the people within and behind stories being told. There is a tendency to let fear, arrogance, or cultural impatience taint one's newsgathering or storytelling. The tendency is not new. Nations have always distrusted foreigners. Just as U.S. immigration policy has, since 2016, targeted people from Middle Eastern countries, so also is there a distrust of Americans in other parts of the world. And the stereotypes we as humans gravitate towards get imposed on others, often stifling more accurate definitions. The result, as we saw in New Zealand as this book went to press, can be deadly.

Religion is often at the center of dissension and distrust. Christianity has been criticized as a religion of exclusivity and oppression. Islam and Judaism have been mischaracterized by those who have disdained or feared the influence of these faiths and the work of their adherents.

This book is the seventh produced by Biola Avenue Press, a division of Biola Avenue Media housed in the Department of Media, Journalism and Public Relations in the School of Fine Arts & Communication at Biola

University in Southeast Los Angeles County. Narratives and images on these pages grew out of a class at that guides students into cross-cultural encounter through in-depth journalism. The book is an attempt to bring light in the darkness — light rather than heat — and understanding where there has been misunderstanding, misconception, paranoia. The book's stance is humility, tied into a faith-driven desire to understand, to bring awareness. All the reporting and research, writing, documentary photojournalism, and page and cover designs are student work. Previous projects in the course, all cross-cultural, are projects of similar long-form journalism, but with varying approaches to people and their stories in Southern California and in two other nations (Haiti and the Dominican Republic).

This book is the first from Biola Avenue Press to include significant portions of historical research. To provide that insight, Biola history students partnered with journalism students to show how where we are, as a community, has grown out of where we've come from. Historical context enriches our understanding of why women, men and children left their countries and came to Southern California. But that context was not easy to find. The history of Middle Eastern immigration to Southern California is an understudied subject with a relative scarcity of resources. Drawing on research tools learned in history classes, students scoured libraries, the internet, and conducted oral interviews to build historical insight. Then, applying historical thinking and historical empathy, these students brought to light the feelings and experiences of often misunderstood and marginalized immigrants from the Middle East as they have navigated often difficult journeys now and in the past.

The book and its accompanying digital media are aimed at helping people everywhere — but particularly those in Southern California — to look again at the people around them of Middle Eastern origin. May it ignite in them a desire to know, to understand, to care about their neighbors in the interactions in which they find themselves as the century unfolds.

————————————

MICHAEL LONGINOW, course instructor for Media Narrative Project, has taught writing, reporting, media ethics, and cross-cultural journalism and other courses since coming to Biola in 2005. Prior to joining Biola's faculty, he taught writing and journalism at Asbury University, where his Mexican-Ukrainian background first began influencing his instruction and approach to curriculum development. He is a former general assignment reporter for daily newspapers in Illinois and Georgia.

TAMARA WELTER, chair of the Department of Journalism, oversaw the Publication, Web and Media Design class that provided page design help for production of this book. Welter's research specialty is cross-cultural media and she provided insight into cross-cultural research. She has done visual journalism and is a former designer for magazines and promotional materials for corporations and government agencies. She has taught the Media Narrative Project alone and alongside Longinow in previous years.

ALICIA DEWEY, chair of the Department of History, is a research expert on the American West, California history, immigration issues and diversity within border areas of the United States. She guided her students into the selected history projects that became chapters of this book as part of a required capstone project for history majors.

foreword

by Jamie N. Sanchez, Ph.D

We are in the midst of a modern-day refugee crisis. The United Nations High Commission for Refugees estimates 68.5 million people have been forcibly displaced from their homes, 25.4 million of whom are refugees.

Statistics, however, fail to educate us about who are refugees. Each number represents an individual with a name and a family. They are men, women, and children who have taken treacherous journeys to safety. In Southern California, many refuges are from the Middle East and fled conflict in order to survive.

After arriving in Southern California, another journey begins. Refugees need basic things like food, education, healthcare, and housing. Many also require legal aid to navigate complicated resettlement policies. But, even more so, refugees need action and compassion from people within their new communities; people who will get to know them as neighbors, learn about their realities, and become a part of their story.

This book will help you do that. The informative chapters will invite you to learn about Southern California's refugee communities. The poignant pictures will give you a glimpse into their lives. The stories will elicit compassion. Let this book spur you on to help address the largest refugee crisis of our time.

JAMIE N. SANCHEZ is Assistant Professor and Program Director of the PhD in Intercultural Studies at Biola University. She worked in China for 10 years before conducting her doctoral studies at Virginia Tech. Her current research interests include refugee studies.

preface

by Olivia Blinn

"We thought that we would be returning in three days. That was more than two years ago."

I'll never forget the day an Iraqi friend spoke these words to me — telling me of the night his family fled their home from the so-called Islamic State. He and I worked at a trauma hospital outside of Mosul, Iraq during the Iraqi Security Forces' offensive to retake the city. Many of our colleagues had similar stories. The heartbreaking stories I had heard on the news became personal that night. Now, they were the stories of my friends.

Just over a year prior, I was working in Greece with refugees and migrants, primarily from the Middle East. I listened to story after story of families fleeing war, desiring safety for their children and wanting freedom from a life of fear. Of these stories, I was not worthy.

At the end of my time in Iraq, I tattooed 'جار' on my right wrist — 'neighbor' in Arabic. It serves as a reminder of my lifelong endeavor of learning to love my neighbor. The word being in Arabic is an act of unlearning — reckoning with the fact that growing up in a post-9/11 America had implicitly taught me to fear "the other."

When it comes to our Middle Eastern neighbors, may we show up and listen well. We cannot listen if we are talking, insisting we know how the world should work. I have learned that we cannot legislate compassion. Compassion requires us to step outside of ourselves and our comfort zones.

I hope you find yourself between these pages, but I also hope you don't. Instead, may you be welcomed into a world that's not your own and inspired to act. Introduce yourself to the neighbor you've never met. Listen to music in Arabic, Hebrew, Kurdish, Persian or another language you don't speak. Eat a meal, the name of which you're not sure how to pronounce.

In doing so, may you discover that there's a community of people waiting to invite you in for a cup of tea.

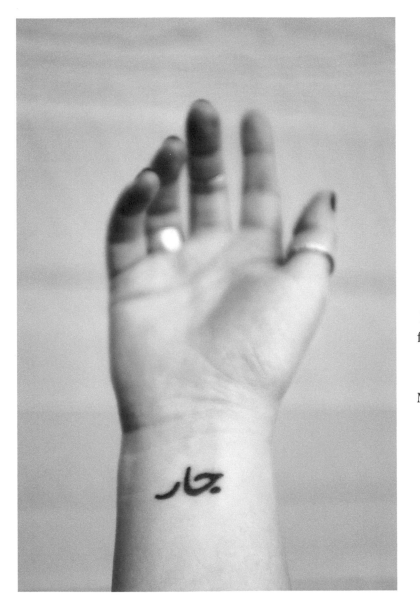

OLIVIA BLINN is a humanitarian aid worker who has responded to crises and conflicts in Cambodia, Nepal, Greece, Ecuador, Haiti, Iraq and the Federated States of Micronesia. She holds a Bachelor's of Arts in Journalism from Biola University ('14) and a Masters of Science in International Disaster Management from The University of Manchester ('19) in the United Kingdom.

We complete this book in loving memory of Professor William "Bill" Simon, who was instrumental in our development as journalists, storytellers, and people. His beautiful inspiration and constant encouragements equipped many of us with the courage and skills to engage this project. His legacy of love, laughter and hard work will continue throughout our lives and careers.

Rest in peace professor.
2.28.19

table of contents

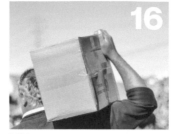

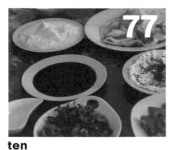

today, looking forward

photo series: agencies at work

Flyers for programs and services printed in Arabic at Voice of the Refugees. (Caitlin Gaines)

Father Mark Hannah of the Coptic Orthodox Diocese is heavily involved in aiding newcomer adjustment to Orange County. (Alex Brouwer)

Glenn Peterson, Office director at World Relief Southern California, examines a recent call to support refugees from evangelical leaders. (Caitlin Gaines)

An Uplift Charity food pantry volunteer helps carry a family's box to their car. (Caitlin Gaines)

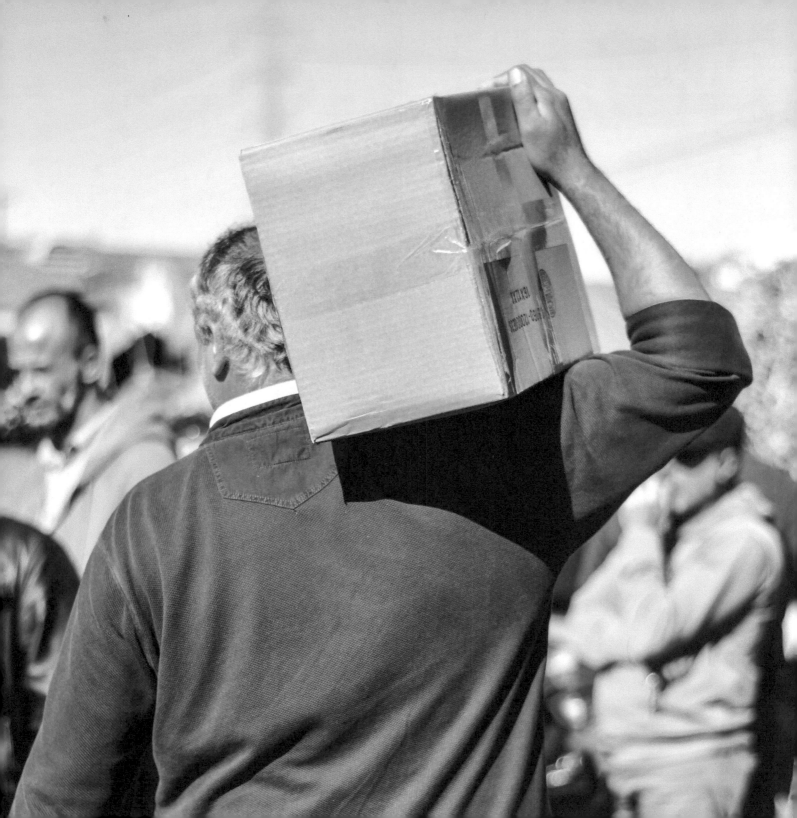

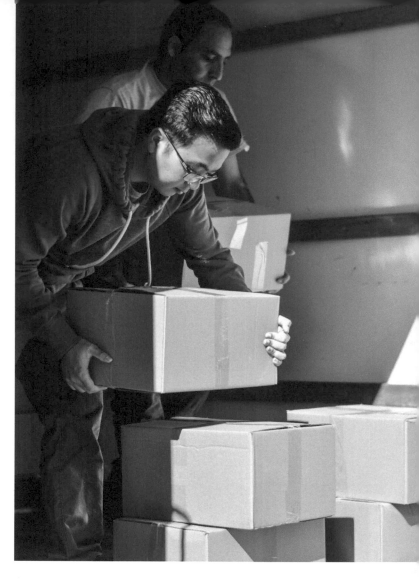

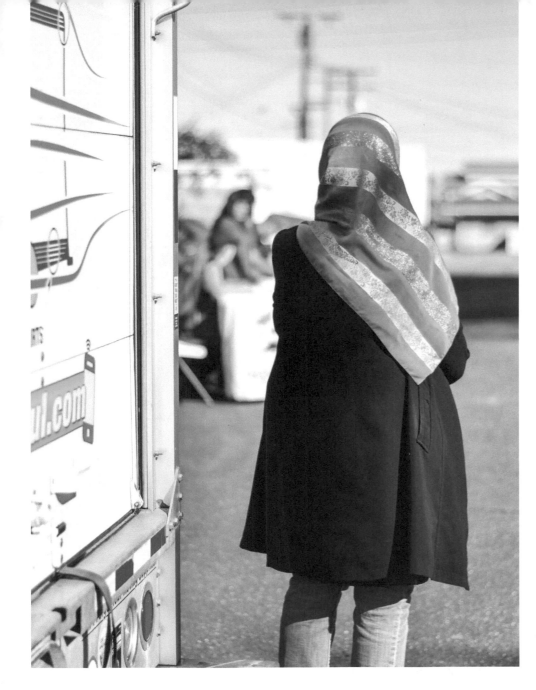

Uplift Charity volunteers set up tables for their food pantry. (Caitlin Gaines)

Uplift volunteers pass out pre-packaged boxes of food from the back of a U-haul. (Caitlin Gaines)

A Muslim woman waits for her turn to receive food (Caitlin Gaiines)

Some of the first to arrive at Uplift's food bank, two friends engage in conversation before registration. (Alex Brouwer)

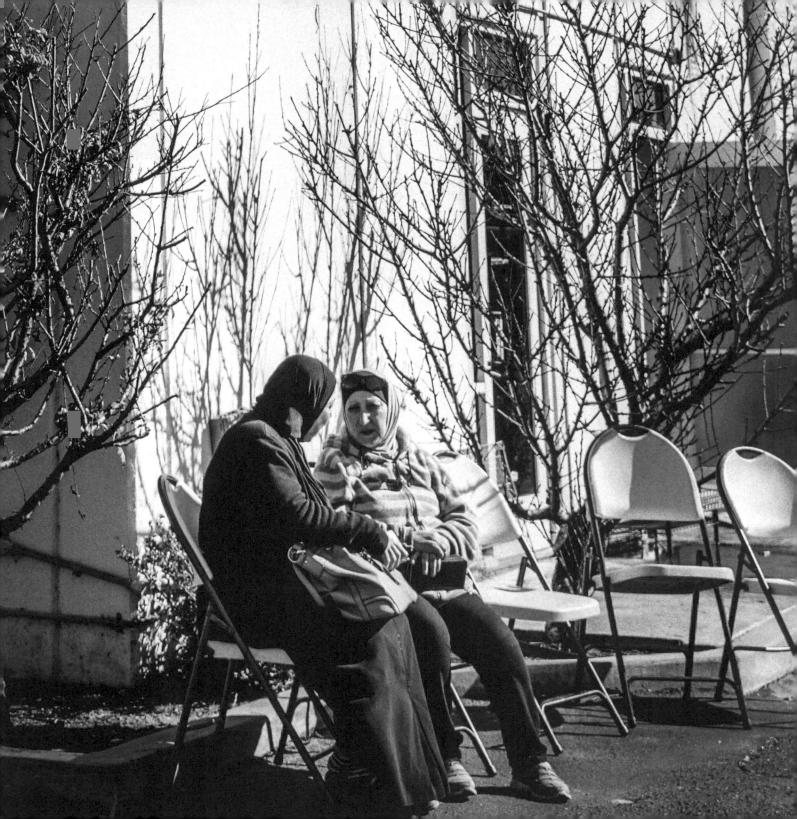

After receiving their food boxes, two women look on as others follow suit. (Alex Brouwer)

An Uplift employee gives directions to volunteers. (Alex Brouwer)

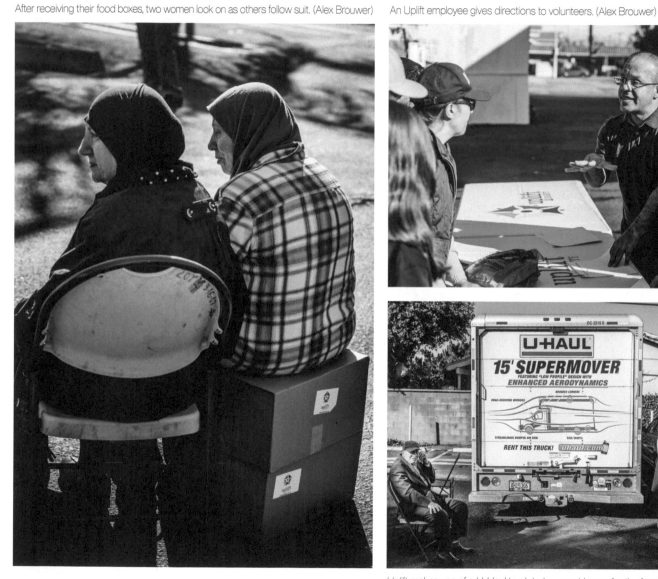

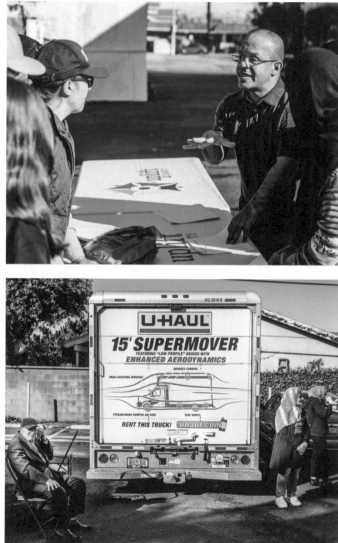

Uplift makes use of a U-Haul truck to transport boxes for the food pantry. (Alex Brouwer)

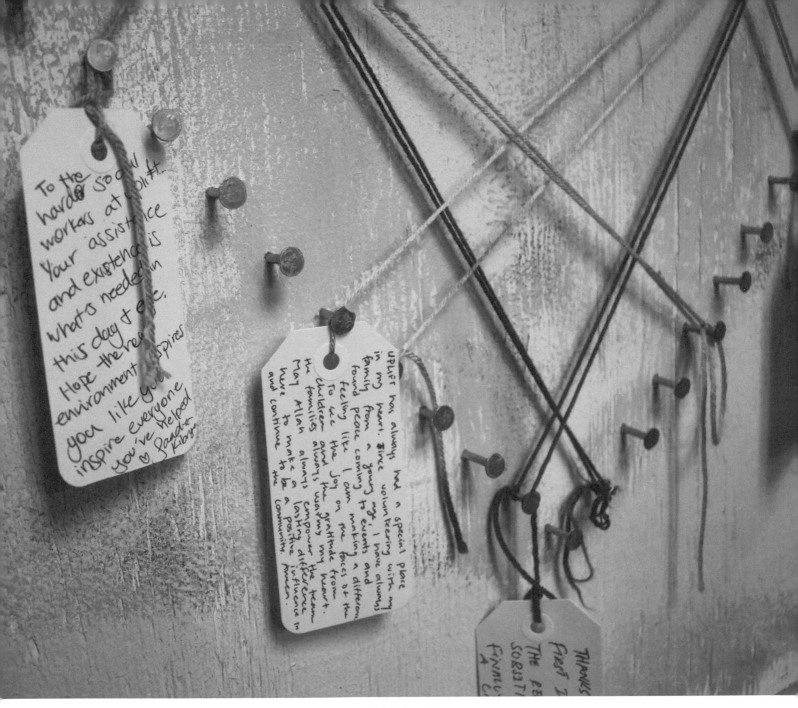

Handwritten thank-you notes in Uplift's office from families the charity has served. (Caitlin Gaines)

Samir Mohamedy, Operations & Case Manager at Uplift Charity, displays a certificate of recognition from local representatives for the charity's work in the community. (Caitlin Gaines)

A list of donation needs in the Voice of the Refugees' offices. (Caitlin Gaines)

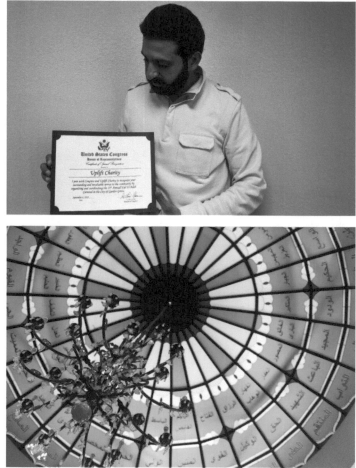

A chandelier hangs from the inside of the dome of the mosque at the Islamic Society of Orange County. Inscribed in glass on the ceiling are one hundred of the names of God in the Muslim faith. (Hannah Clark)

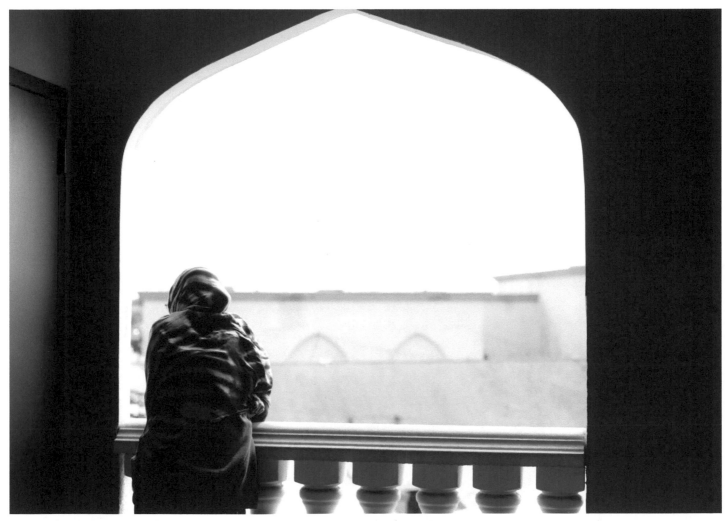

A woman looks out over the balcony onto the grounds of the Islamic Society of Orange County after Friday prayer. (Hannah Clark)

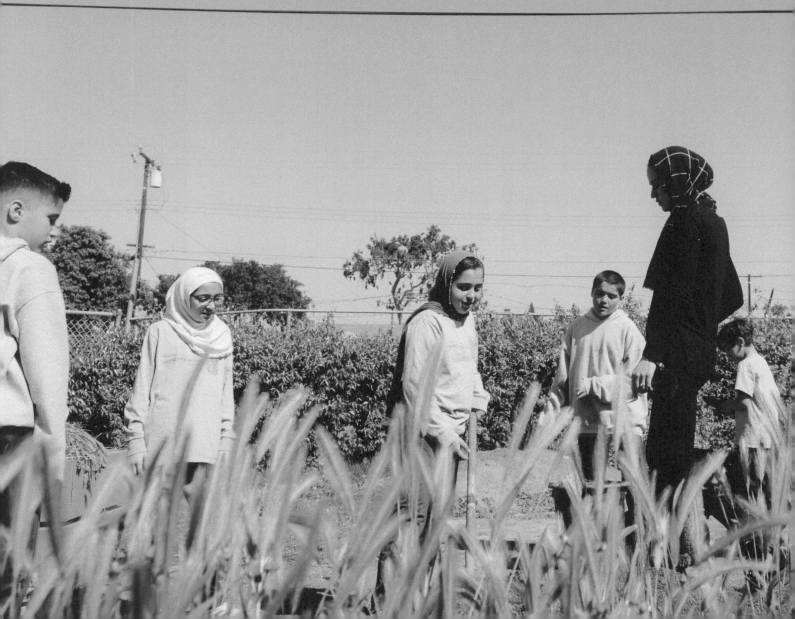

The students of Orange Crescent School prepare to weed out and prepare the soil of the garden they are planning to grow a meal at the end of the school year to celebrate their work and encourage a healthy lifestyle. (Kathy Baik)

children and schools

by Fiona Gandy

"If anything, they really need more emotional support than anything. Leaving their families and coming from a war-torn country puts a lot in them." -Maisa Youssef

When Jodie Stock, a first-year psychology and business double major at Biola University, was traveling with her family to the United States, she did not expect the discomfort that would be met by Transport Security Administration (TSA) officers. She recalls being pulled aside for questioning and additional security clearance. They checked her hands for chemicals to see if she had been making bombs back in her home country, Pakistan. She says that although the experience was not necessarily terrible or cruel, she realized that as soon as the officers had made the connection of Stock coming from Pakistan, she felt like she had something to hide when she really did not.

Stock, an ethnically Chinese 19-year-old, was adopted at the age of 1 by an American family and grew up in Pakistan. She recalls having trouble with TSA agents whenever she would be traveling with her family due to "Quad S" also known as "SSSS," a way for TSA to label people from the Middle East. There would be a special indication on her boarding pass stating that she is a part of "Quad S" and this will send out a signal alerting officers to investigate her bags and pull Stock aside for questioning.

"SSSS stands for Secondary Security Screening Selection and it appears on a passenger's boarding pass when they've been selected by TSA's Secure Flight system for enhanced security screening," a TSA spokesman told Business Insider. "Secure Flight is a risk-based passenger pre-screening program that enhances security by identifying low and high-risk passengers before they arrive at the airport by matching their names against trusted traveler lists and watchlists," the agency said.

Regardless of whether a child is classified as an asylee, a refugee, or a migrant, there are challenges that they face in some parts of life in the United States. Just like Stock's story, airports are a part of that.

According to UNICEF, the number of child refugees has grown nearly 80% in just 5 years. Between 2010 and 2015, the number of child refugees under The United Nations Refugee Agency's

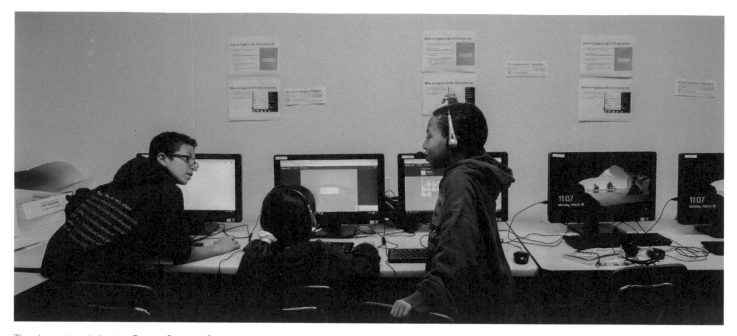

The elementary students at Orange Crescent School share jokes with one another as they practice their typing skills during Computer Lab. (Kathy Baik)

It's just our way of life and we don't get offended by it because that is reality.

care and protection increased by 77% from 5 million children to a startling 8 million. UNICEF states that children represent a "disproportionate fraction" of the world's refugees. They make up less than one-third of the world population. This means that 1 in every 200 children in the world is a refugee and nearly 1 in 3 children living outside the country of their birth is considered a refugee.

What has caused this spike in the number of refugee children throughout the years? In 2015, World Economic Forum reported that wars and persecutions have driven more people from their homes. In the past five years, at least 15 conflicts have erupted. In 2015, around 45% of all child refugees under UNHCR's protection came from Syria and Afghanistan. In some regions, the cause of fleeing the country includes natural disasters like earthquakes, drought, or famine. But violent conflict and persecution, some of it based on ethnicity or religion, are also causing people to flee their homes.

With the feeling of not being welcomed to the United States, even with her American citizenship, Stock has always been taught to emphasize how she attended a Christian school back in Pakistan when interviewed by a TSA agent. "We're used to people viewing Pakistan negatively. It's kind of just our way of life and we don't get offended by it because that is reality. For us, it was more of an inconvenience because we had to sit around waiting, always worried that we're going to miss our flight," she recalls.

Even though it is hard for immigrants like Stock, there are families from the Middle East

who have found ways to adapt and become part of the cultural landscape in the United States. Schools like St. Luke Coptic Orthodox Christian Academy in Yorba Linda help with that. Therese Kdeiss, Director and Lead Teacher, creates a safe and loving environment for these children.

"What do you want to be when you grow up?" asks Kdeiss. The responses come immediately.

"A construction worker!"

"I want to be a Mommy!"

"I want to be in the Olympics!"

"I want to be a superhero!" shouts the children of St. Luke Academy with pride and joy.

A tiny school situated in a beautiful neighborhood located behind a Coptic Orthodox church, St. Luke Academy is the first Coptic

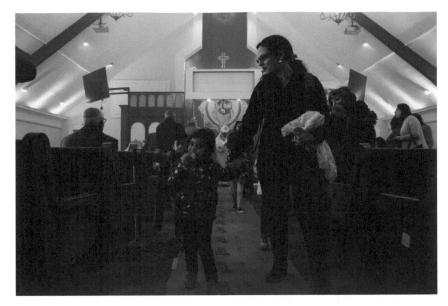

Sofia from the Noah's Ark class of St. Luke Orthodox Coptic Christian Academy, walks back to her class after Wednesday Chapel with her teacher, Jina Alarja. (Kathy Baik)

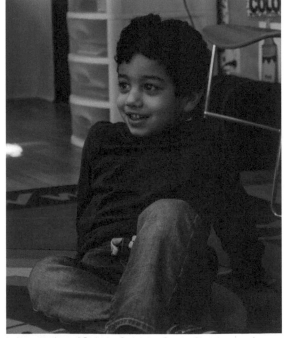

Luke, a student of St. Luke Orthodox Coptic Christian Academy, introduces himself as part of the Noah's Ark class. (Kathy Baik)

Orthodox school in Orange County open to students coming from all faiths and backgrounds. As you enter the school, you'll hear the laughs and cries of children all around preceded by a warm and welcoming greeting from one of the staff members there.

Only 16 students currently attend the academy with ages ranging from 18 months to 5 years old. What's unique about St. Luke Academy is that almost all of the children who attend are of Middle Eastern descent.

"Most of the kids are from Egypt because the Coptics are Egyptian. We have one Lebanese and I'm personally from Jordan, so also the Middle East. We do have Americans, a Korean family, Romanian Orthodox," said Kdeiss

Although a majority of the children who attend St. Luke Academy are Middle Eastern, Kdeiss emphasizes that "children are children." Kdeiss, a passionate educator, has been teaching for years. She has taught children from various backgrounds and nationalities. Regardless of where they come from or how they were raised, Kdeiss states that all children play the same way and learn the same way. They also have hopes and dreams.

Kdeiss' smile radiates warmth and kindness as she talks about the children she teaches at St. Luke Academy. She values creating a comfortable

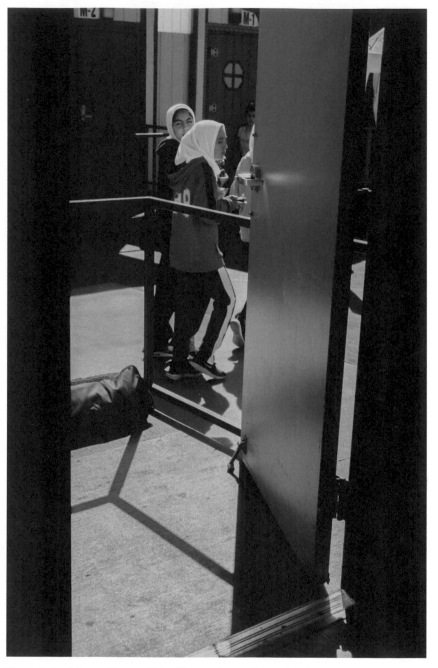

The students of Orange Crescent School like to walk around during break and check in with the administration to chat and ask questions. (Kathy Baik)

and safe environment for her kids. The curriculum which combines Coptic Christian teachings as well as "STEAM (Science, Technology, Engineering, Arts and Math) focused" education. According to St. Luke Academy's website, the school aims to create a valuable link between school, church, and home for its students, with the intention of connecting the gospel of Christ to daily school life.

Another school with a faith-based reason for serving children is Orange Crescent School in Garden Grove. According to the school's website, their mission is "to provide students with academic and moral excellence in an Islamic environment." This school intends to develop their students' self-identity as Muslim-Americans in order to impact the world. The school teaches preschoolers to 8th graders with more than 265 students and currently has six refugee children. Maisa Youssef, Principal of Orange Crescent School in Garden Grove, California says these refugee children really need more emotional support than anything. With leaving their families and coming from a war-torn country, experiencing trauma at a young age has become the norm for these children and their families.

At this school, refugee families receive great care and attention, especially when it comes to paying for school. Youssef states that during the enrollment process, refugee families will let her know of their current situation. Usually, these families will need financial aid and assistance. She herself will inform the faculty of the school so that they are aware of the family's situation. Youssef makes sure to cover fees for field trips and school supplies.

The refugee children at Orange Crescent School come in having a hard time reading and writing in English and are sometimes even

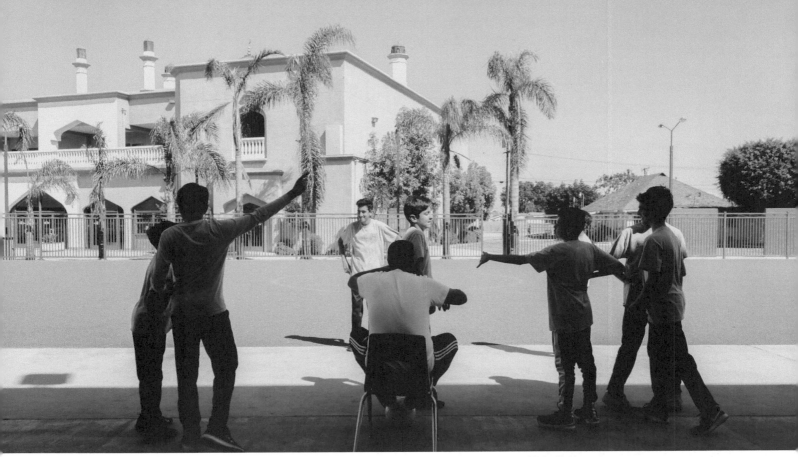

The middle school boys' soccer team at Orange Crescent School eagerly await to begin practicing their favorite sport.. (Kathy Baik)

illiterate in their own home language due to receiving no education in their home country. The United Nations Refugee Agency reports that refugee children are five times more likely to be out of school than their non-refugee peers. Since 2017, 3.5 million children and adolescents were not in school, according to the report.

Most of the children at Orange Crescent School come from Syria, Afghanistan, and Jordan. Since all of the children wear uniforms, most of the children aren't even aware of who is a refugee amongst the students. Youssef says that the younger kids will not show much care towards their refugee friends. However, in middle school, the refugee child may communicate that they are a refugee to fellow peers. Youssef recalls how comforting it is that there isn't any different treatment towards those who are refugees by those who aren't.

Shevin, a Kurdish Syrian refugee woman , in her El Cajon home. The transition from Syria to Turkey to the United States has not been easy, but she uses language, art, and hospitality to help herself and her family find a sense of belonging and create a home. (Hannah Clark)

women and girls

by Rachel Diaz

STILL, SHE CALLS

I come not from splintered hovels nor a scarlet
hostility, and yet, the fibers of my brown curls
are lethargic, parched, ready to bathe in oil
from my grandmother's kitchen. She spreads it
through my ringlets with tender fingers, dousing
them with home, the very home bereft from my
voice that howls america even as my lungs
flood with levantine air. And as I eat the red
meat, raw, with my hands perhaps, I know my
madonna feet have stepped not on frayed land, but
my body, forty-nine years removed, remains
wrapped in shades of olive, wrapped in her
warmth, wrapped in her arms that hold the
world.

-Nasma Kublawi

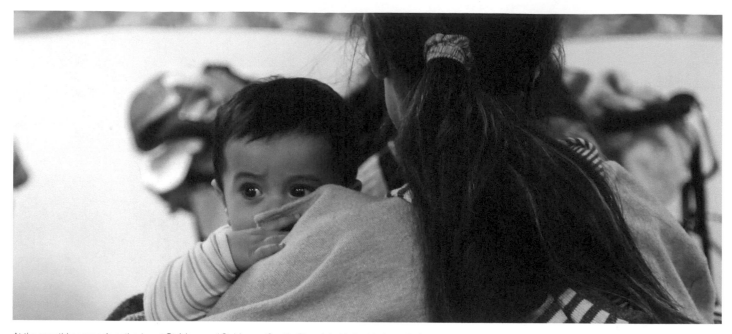

At the monthly women's gathering at St. Mary and St. Verena Coptic Church in Yorba Linda, multiple generations interact, sharing a sense of community and familial love between church members. (Hannah Clark)

I didn't have anyone to welcome me, so I want them to feel welcome.

Gold detailed plates delicately wrap around food on the crowded table set by Shevin, a Kurdish refugee from Syria. On the table are homemade yogurt, piping hot Iraqi bread alongside pita, date molasses and thyme both dried and soaked in olive oil for garnish. Shevin pours tea in small glasses with the same gold detailing as the baskets holding the food. Hospitality is cherished here. Her guests rip bread and use it to scoop up the ingredients on each plate.

Shevin's house is warm, her art decorating the walls alongside red floor-length curtains. Her house is full, but it has not always been like this. Shevin came to El Cajon in 2016, during a large influx of Syrian refugees fleeing the civil war and the destruction from The Islamic State of Iraq and Syria (ISIS) that sparked as early as 2011. Shevin reflects on her time in Syria with tears in her eyes and as she uncovers the memories that flood her mind, she holds her heart, saying it races just as fast. "You are here now," a trusted friend reminds her. When ISIS moved through the Kurdistan region, some women took up arms. Female Kurdish fighters started fighting in Women's Protection Units and they played a role in fighting against ISIS in the northern parts of Iraq and Syria. Aside from women fighters, women living in areas of conflict were in dangerous situations and not only had

to take care of themselves, but their families as well. According to the United Nations Refugee Agency, about 50 percent of refugees are women and girls. The obstacles that women have to face in refugee camps are dangerous as they are displaced. Women staying in refugee camps are vulnerable to gender-based violence.

Shevin has built a home from a painful past. Southern California saw one of the biggest arrivals of Syrian refugees in the United States and the International Rescue Committee had a difficult time relocating refugees into proper housing. Shevin recalls staying in a small motel, wondering if this

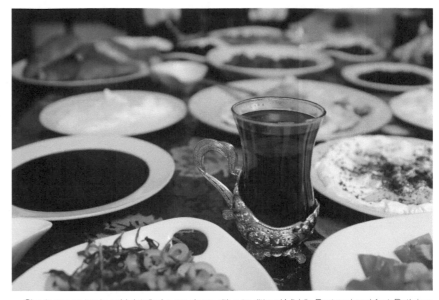

Shevin serves tea in gold detailed cups along with a traditional Middle Eastern breakfast. Both her kitchen and coffee tables were covered in food and treats as a token of love and hospitality. (Hannah Clark)

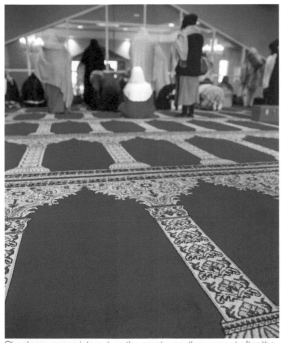

Shoeless women interact on the ornate, spotless carpet after the Jumu'ah (Friday congregational) prayer at the Islamic Society of Orange County. (Hannah Clark)

was all there is to America. She made a home with what she could. Originally from Aleppo, Shevin fled with her family to Turkey, working as a translator because she picked up Turkish quickly. Here, she takes English classes four times a week and works hard to speak it as much as she can. Shevin is one of the best English speakers in her class, but accepts minor correction from a trusted "auntie."

Many refugees and migrants face linguistic barriers in their new country, but Shevin accepts the challenge. Alongside her husband, who is a fashion designer, she works well with her hands. When she is not participating in English classes and taking care of her children, Shevin hand embroiders and creates small home goods to sell at farmers markets. This is how she met Mary, an American woman and artist who runs an organization that has a vision for community building through art. She explains that the other benefit of these artistries is the healing process as they have had traumatic stories from everything that happened in Syria and other countries they went to before they came here. "Our vision is so that women

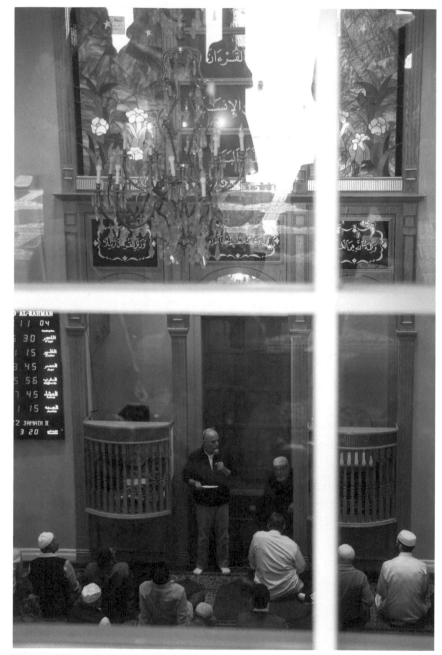

Women and men often pray separately during prayers in mosques to observe the Muslim value of modesty and prevent distractions, as communal prayer involves standing shoulder to shoulder and prostrating. Women praying upstairs at the Islamic Society of Orange County are able to observe the leader of the prayers and the imam giving the teaching through a large window. (Hannah Clark).

and girls have a sense of value, validation, and empowerment," says Mary, which she explains is through coming together in community and learning new ways to create and contribute.

Not only is Shevin an artist herself, but she encourages her children in it. She grabs her son's recent paintings and shows his work. The once tearful Shevin smiles with strength and pride as she speaks about her son. Her son was sick in the hospital during their time in Turkey, and to distract him from the fear of being hospitalized she gave him a pen and paper. He began drawing "That's when I discovered his talent, he was only 3 ½ then, it got him through a difficult time," Shevin says. Art has proven to be a healing outlet for the family.

As each person's story is different, so is "each community different" says Joy, a Syrian refugee originally from Damascus. She is 17 years old and recently married, her sparkly Hijab matching the shiny ring on her finger. She discusses the culture shock of her life now in America. Her experience in the public school system was positive and she says that she enjoyed that everyone is allowed to have their own opinion and that they listen to what each other says. Joy does not attend school anymore because she takes care of her household, but is in the process of getting her GED.

The culture shock that Joy is going through is not only one of education,

Women gather outside the prayer hall at the Islamic Society of Orange County. The arches and minarets represent the architectural heritage of the Muslim faith. The Muslim declaration of faith is printed in green above the entrance. (Hannah Clark)

although she mentions that women in America are more invested in their education than back in Syria. She is sitting on the edge of adolescence and adulthood as she sips her Caramel Frappuccino at the local Starbucks. She says she wants to honor her family's values but sees the diverse ways American girls live like she saw in the school she attended. As she flashes her phone, she says that there are parts of her that have changed and modernized.

Through Shevin and Joy, society is able to see the strength and perseverance that these women are clothed in. They have overcome great obstacles to get to where they are today. This process is hard and easing into a new home is often difficult. Their community strives to create a safe space to welcome refugee women and girls, to support them as they ease into a new environment, allow them to create a sense of home with one another, and inspire each other's hopes and dreams. Together they are building a new foundation of what it means to be home. A friend and refugee from Lebanon who preferred not to give her name reflects on her own reasoning for her intentional relationships with the refugees in her community, "I didn't have anyone to welcome me, so I want them to feel welcome."

Surrounded by the glass of brightly colored pipes and bongs, Maher Rajab stands in the middle of World Smoke Shop in Anaheim, a business owned by his uncle. (Cooper Dowd)

men and boys

by Brian Marcus

"We always feel like we're the next chapter of our family. No one's gonna do it for you. It's now or never for me."
-Maher Rajab

Maher leans against the glass counter of his uncle's hookah shop in Anaheim. A sweet, fruity aroma lingers faintly in the air. Glass tubes and painted marble bowls lay on tables, taking up half of the space in the room. He spends a lot of time in the shop, but he dreams of getting into the entertainment or news industry. He has been branching out from the traditional views of his parents, which sometimes makes Maher feel out of place at home. This generational divide is evident within many newly arrived refugee families, as well as those who have had more time to adjust, such as Maher's parents. Refugee fathers face the unique experience of fighting a growing cultural divide to keep their families together. The bond between father and son is special, but the challenges of adapting to American culture is testing that relationship. This is the case for one of the fathers who attends weekly English classes at Access California Services in Anaheim.

Zatal goes by his first name to preserve confidentiality. America is better than he thought possible, but the transition has been painful. The greatest challenge, as is the case with many other refugees, is learning English. Zatal is laboring towards competency, but he explains that not being able to provide for his wife and four sons is difficult to bear. As a 50 year old father, he feels a responsibility which he is unable to fulfill. His nine year old son is bullied at school, but the teachers don't do anything about it. As the provider and protector of the family, this is incredibly frustrating.

Zatal exudes warmth and openness as he sits in one of the back offices of Access, a styrofoam coffee cup in his hand. He grew up in Iraq, but fled to Syria to escape violence in his home country. Thirteen years later he returned to Iraq, only to move to the United States after

Fadi Arida stands in front of the flurescent window showcasing the pipes and bongs sold at World Smoke Shop. The shop is located in the Little Arabia of Anaheim. Arida prepares the hookah and explains how the smoke mixes with the pomegranate to create a smooth taste. (Cooper Dowd)

> ## " He speaks slowly, but his pride in his children is unmistakable.

ten months. Zatal needs an Arabic translator to convey his thoughts, but when he talks about seeing car bombs and kidnappings his eyes search the room and his voice softens. He is remarkably willing to share about his experiences, but the Access staff translator cuts him off before he gets into personal details.

Two of his sons have jobs while the other two are in school. They have picked up English fairly quickly—which is good for the family, but it has created a barrier between parents and children. Father Joseph Boules, a Coptic Orthodox priest, confirms that this is often the case with newly arrived refugee families. It is much easier for the children to learn English and adjust to American culture, while their parents need much more time.

Mohammed is another man who is learning English at Access, an organization which provides social and economic resources to Middle Eastern refugees in Southern California. He fled from war in his home country of Afghanistan in November 2015. His first language was Farsi, although his English is improving. He actively participates in weekly ESL classes and watches YouTube videos every day to practice. He speaks slowly, but his pride in his children is unmistakable. He has three boys and three girls who are all either working or in college. He wants to emphasize that even though he is a refugee, he and his family are good citizens and are contributing to society.

This sentiment is echoed in Amir Hussain's book, "Muslims and the Making of America." In it, Hussain, an immigrant to Canada from Pakistan, debunks the common misconception that refugees are "dragging us down" by taking a disproportionate amount of aid. In reality, most refugees came from a middle or high class background in their home countries and work extremely hard to pay their own way.

Orange County is home to dozens of organizations, many of which are committed to giving much needed aid and work opportunities to the growing refugee community.

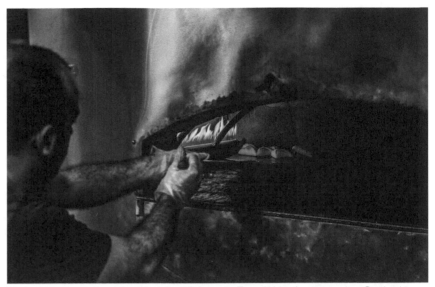

Nader Hamda rotates a fresh batch of Fatayer in Forn Al Hara's pizza oven. Cooked to order, Fatayer is a traditional Middle Eastern pie that is stuffed with either meat, spinach or cheese. (Cooper Dowd)

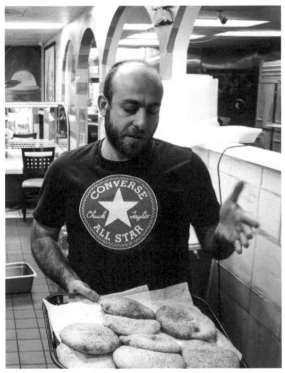

Nader Hamda explains the process of making a common Arabic desert called Ka'ak. This is one of many Middle Eastern baked goods sold at Forn Al Hara. (Cooper Dowd)

Archangel Michael Coptic Orthodox Church is one such organization that is seeking to follow Jesus' example and help in any way possible.

Father Mark Hanna pulls into the parking lot in a white minivan, a cross dangling from his rearview mirror. After pulling open the sanctuary door he pauses, the spicy smell of frankincense creating a sacred, pensive atmosphere. He bows his head and crosses himself before continuing. Hanna grew up in Egypt and moved to the United States in 2011. He is both thoughtful and playful as he mixes refugee stories with insurance advice. His Coptic Orthodox church in Santa Ana has been the helping hands and warm heart of Jesus to refugees for as long as he can remember. Hanna points out that he doesn't use the word "refugee" or "asylum seeker." Rather, everyone his church helps is known as a "newcomer."

Father Hanna has three sons. One day they were driving while playing "punch buggy." The rules are simple; whoever spots a Volkswagen buggy gets to punch the others. It's an entertaining game, as long as no one gets hurt too badly. The game got out of hand—at least in the eyes of a woman in a nearby car—and the police were called.

John O'Brien, author of "Keeping it Halal," writes that many young Muslim men are focused on managing their "culturally contested lives." They want to be normal teenagers in America but are also expected to be good, practicing Muslims who don't miss their prayers. They try to present a "low-key Islam," where they deflect attention while maintaining their Muslim identity. This can be difficult to do when young Middle Eastern men are profiled by appearance, as was the case with Hanna's sons.

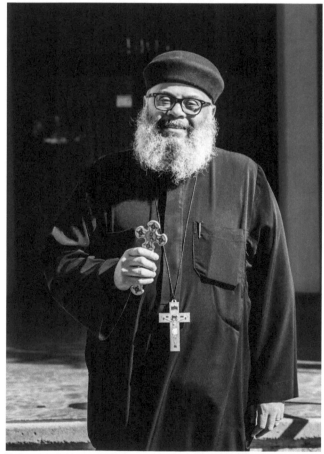

Father Mark Hanna stands outside Archangel Michael Coptic Orthodox Church, located in Santa Ana. (Alex Brouwer)

"There are dynamics in every society that are unique," Father Hanna says. His sons had no way of knowing that to someone outside their car, the oldest brother resembled a man abusing his two children. This misinterpretation led to a confrontation with the police where it was necessary to explain to the officers the point of "punch buggy." While this situation ended with the officers laughing, others can lead to jail time. In Egypt, Hanna said, it is respectful to approach a police officer and start a conversation. So when a muscular, rough looking refugee was pulled over in Anaheim, he naturally got out of the car and headed towards the police car to talk. A simple cultural misunderstanding quickly turned into a night behind bars and legal complications.

Father Hanna estimates that it takes two to three years for refugees to adjust past the stage of being grumpy every other day. America is not what many of them expected. Many of them had good jobs in their home countries, and are not expecting to have to work twelve hour shifts at the gas station. Their families back home don't understand either. Most of what they know about the United States is from Hollywood. "They think that relatives in America are living on a beach in Malibu," Hanna says. Although the first several years are demanding, many families have transitioned well. Newcomers are now successful doctors, restaurant owners and corporate executives. The generational rift seems to close over time as well. The Migration Policy Institute estimates that it takes resettled refugees 10 to 20 years to reach an income comparable to that of U.S. born citizens. It is a long process, and often painful, as refugees experience language barriers, discrimination and trauma.

Mohammed Alam is known for his incredible generosity and his delicious Lebanese food. He is the owner of Forn Al Hara, one of the first restaurants established in Anaheim's Little Arabia. "His kindness is crazy," his son Rashid says when asked what he has learned by watching his father. Rashid is sitting at a table inside Forn Al Hara, where he works on

Rashid Alam discusses his life as a son of an immigrant and his relationship with his father Mohammed Alam (Justin Johnson)

Saturday nights. He remembers his father teaching him and his friends how to make za'atar pizzas in the restaurant ovens. Rashid explains that Alam always made time to spend with his family. Based on the handshakes, hugs and hellos Mohammed receives from his customers, it is evident that he has made time to develop friendships with them as well. He "doesn't expect anything in return" and gives freely. He says that he has been very fortunate during his 51 years in the United States. The longer he stayed, the more success he found. Alam's story is very different from Maher's, but they are both valuable members of the same community.

Maher and his friends often hang out at the hookah shop in Little Arabia. He speaks casually—his language typical of the hip hop community he references. "I'm Arab as f--- but I have friends from other cultures." He says he is not as "old-school" as his parents, but nevertheless he has found a community in Little Arabia, as have Alam and his family. All the shop owners know each other, and frequent each other's stores to eat and talk. This is a place for both young and old, a Middle Eastern enclave that has become known as "Gaza strip" by its occupants.

Many newcomers worry about their children leaving behind their culture or their religion. Father Hanna often counsels parents through this adjustment process, which can be feel frightening. Maher, however, is an example of a self-described "Americanized" young man who has kept his family's Middle Eastern roots. He grew up in Southern California, surrounded by American culture and a diverse group of friends, but he knows where he came from.

One of the barbers walks through Forn Al Hara waving hello to the owner of Scoop & Juice. Mohammed welcomes a family through his doors. "Hello old friends!"

Flags of Middle Eastern countries flap in the breeze atop a restaurant in the Little Arabia District of Anaheim. Little Arabia represents many cultures of the Middle East. (Brenna Khaw)

laws and legal aid

by Julianna Hernandez

"When a stranger sojourns with you in your land, you shall not do him wrong. You shall treat the stranger who sojourns with you as the native among you, and you shall love him as yourself, for you were strangers in the land of Egypt: I am the LORD your God."
- Leviticus 19: 33-34

The office is simple. It is not a high rise in Downtown Los Angeles boasting of its legal and monetary achievements. Instead, the walls boast of the families they have helped over the years, lined with art of refugee children and a painting of monarch butterflies, a symbol of immigration. Entering the building, a quote hangs above the archway in Arabic, Spanish and English, "No matter where you're from, we're glad you're our neighbor." The office is simple, but it speaks of relief, of help for migrants.

This building is home to World Relief of Southern California, which aids in immigrant legal services and refugee integration. This center that specializes in the refugee resettlement of families is in Garden Grove, California about 15 minutes up on the road on Brookhurst Street from "Little Arabia" in Anaheim. The advocates and employees of World Relief often have their own migrant story too; one example is Heather Kwak, the agency's Immigration Program Director, who helps clientele, whether immigrants, undocumented immigrants, refugees or asylees, with family-based legal immigration services.

Kwak was born in the United States, but her family immigrated from Korea in the 80s. She believes this is at the core of why she helps advocate for families. Before World Relief, she also interned and worked at International Rescue Committee and returned to her hometown to meet with clients she saw herself in.

Heather Kwak pointing to the art that is done by children at World Relief. World relief is an organization that focuses on equipping local churches and community partners with resources for humanitarian aid. (Julianna Hernandez)

No matter where you're from, we're glad you're our neighbor."

"When I have a family [as a client], and the 13-year-old child is interpreting for the mother. I relate with that," said Kwak. "I continue to. Up until this day, I am the interpreter for my parents, even though, they've been here for over 30 years. And so, just that immigrant journey, whether you were the child of or were born here, or you came at a young age, it always is the seeing the parents, because I see in that in all of my families that I assist here."

Kwak advocates for a myriad of people from various countries, mostly Hispanic, but Middle Eastern as well. Her clients come from Iraq, Iran, Afghanistan, Syria, Kuwait, Jordan, Mexico and El Salvador. The cases range from a legal resident seeking citizenships, to those seeking Legal Resident Cards or also known as Green Cards. She also works with those inquiring about Deferred Action for Childhood Arrivals.

World Relief also offers humanitarian based legal aid. They help with U-Visa, which is a nonimmigrant visa set aside for victims who have suffered mental and physical abuse, and aid to law enforcement in an investigation. T-Visa allows victims of human trafficking and family members to live and work in the U.S. temporarily. Violence Against Women Act secures aid for women who have been

sexually assaulted whether they are a citizen or not.

Kwak said her job is to explain the facts of each immigration case.

"Their immigration history," said Kwak. "Their criminal history if they have any, and see whether or not, based on immigration law, if there's a pathway for them to get some kind of status here in the U.S. If there's an assessment and there is some kind of relief, and I can confidently tell that to the person and get them on a path to do the forms."

If a client is undocumented, hearing that there is a way to get a Green Card invokes relief explains Kwak. For many a

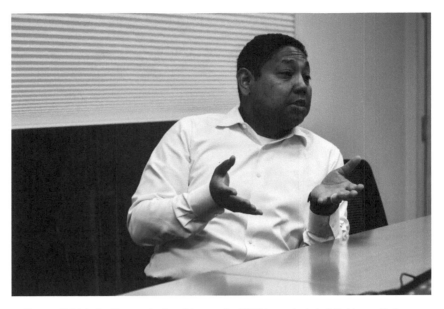
Eugene Fields is the Communications Manager for CAIR, he works to build bridges with the community and media through various digital and creative platforms. (Brenna Khaw)

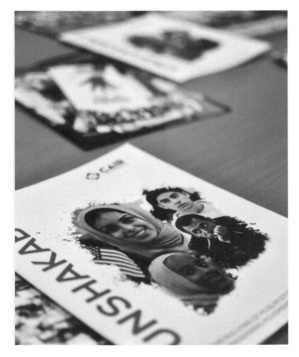
CAIR is an organization dedicated to serving the Muslim and immigrant communities. (Brenna Khaw)

Green Card equals stability says Kwak, and their status matters to them in terms of finding a job and in their emotional and psychological health. But in about two to three consultations a week, she finds there is no relief available for her client.

World Relief is not the only organization to help with immigration legal services. The Council on American-Islamic Relations legal services team intakes 1,200 cases per year and takes about four calls a day according to their communications director Eugene Fields. While CAIR mainly focuses on advocacy for Muslim rights in America, the office in Orange County has four full-time lawyers and more law clerks on staff.

Additionally, AmeriCorps Program Director Suzanne Baker stated once lawyers have helped immigrants obtain the opportunity to apply for Green Cards, organizations like Access California help clients fill out the paperwork for it. A migrant has to obtain an immigration status first.

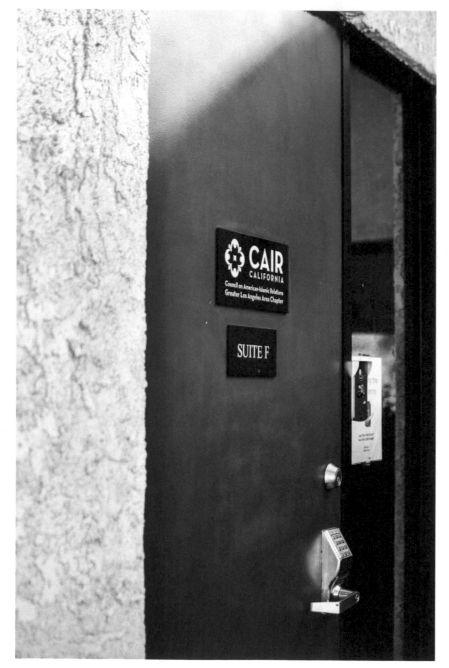

CAIR's mission is to enhance understanding of Islam, protect civil rights, promote justice, and empower American Muslims. (Brenna Khaw)

What makes it hard?

A Green Card allows an immigrant to live permanently in the United States. After five years, the resident can apply for U.S. Citizenship or Naturalization.

Whether a person is classified as a refugee or an asylee has legal ramifications. Refugee as stated by the United Nations Refugee Agency is "a person who has been forced to flee his or her country because of persecution, war or violence." This person must also have well founded fear, and he or she can be deemed a refugee before entering a new country. An asylum seeker is one who flees to find sanctuary in another county. By international law, both refugees and asylees can work in a sanctuary country and are entitled to legal aid. However, only asylees can claim their status while in their sanctuary country and receive what is known as a credible fear interview says Kwak. In a credible fear interview, asylees must establish that have been persecuted or have a well-founded fear of persecution or harm on account of their race, religion, nationality, membership in a particular social group or political opinion if they returned to their country states the Department of Homeland Security. According to U.S. Citizenship and Immigration Services, refugees and asylees can apply for a Green Card if they have been in the United States for the least a year.

But under the Trump administration the number of refugees allowed into the U.S. has dwindled vastly. According to the

Lina Kayali, the citizenship and immigration coordinator for Access California. She helps people who are immigrants and looking for citizenship within the U.S. (Brenna Khaw)

New York Times, the U.S. State Department cut the number of refugees allowed in to an all time low of 30,000 for 2019. In 2018, the number was capped at 45,000 along with Trump's Muslim Ban to stop Syrian refugees from entering the country. At the end of the Obama administration, there was a 110,000 refugee cap, and under George W. Bush administration, 70,000 were allowed refugees in.

But while the number of refugees allowed in the U.S. has been slashed significantly, the number of displaced people in the world is not decreasing. The UN Refugee Agency states that 44,000 people are forced to flee their countries every day. Some come to the United States, and often without status to get a better life. These people seek out organizations like World Relief, CAIR and Access California.

Kwak describes refugees as resilient This might not even be the first country they came to. it could be the third or fourth. They are navigating the world to find a place that's safe, where they can live.

MANAGER
←

housing

by Caleb Aguilera

"I had a guy. I gave him a ride ... he asked me where I'm from because I look Middle Eastern, but I have the cross hanging in my car. He said, 'Thanks for the ride, but it's funny because if we were back home we'd probably have to kill each other.' And I said, 'Yeah, how about that?'"
-Kevin Hitti

On July 1, 2006, 12-year-old Kevin Hitti entered the U.S. for a two-month vacation that would entirely alter the course of his life in ways he never could have expected.

He left his home country of Lebanon with his mother and brother and came to Riverside in Southern California to visit his uncle. Less than two weeks passed and July 12 came, Hitti's 13th birthday. But on that same day, war broke out back home. The July War — as it is known in Lebanon — erupted with devastation that shook the entire country. Hezbollah, an Islamic political and militant party based in Lebanon, fought with the Israel Defense Forces in Lebanon and Northern Israel. The 34-day conflict resulted in at least 1,109 Lebanese casualties — most of whom were civilians — 4,399 injured and an estimated 1 million displaced, according to Human Rights Watch.org.

This war was sudden and unexpected for Hitti and his family. He was cut off and left thousands of miles from the only home he ever knew. He was separated from the house he lived in, from his culture and friends. As if that was not hard enough, he was also separated from his father who stayed in Lebanon because he never got approval to come to the U.S. in the first place.

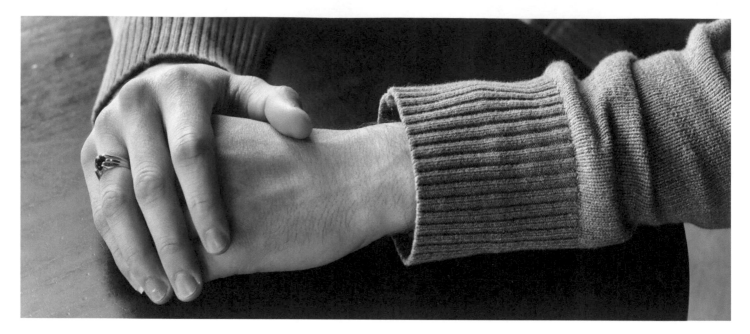

Hitti sits down shares his story of coming to the United States at a Southern California coffee shop. He asks that his face not be shown for protection of his identiy and for his family. On his finger he wears a ring given to him by his father containing an eye of the tiger stone. (Molly Bolthouse)

 He wants to be certain that he is not going to lose everything he has worked for, the new home he has built.

"It was horrible," Hitti said. "I was thinking about my friends, thinking about my family and I just thought, 'There's no way [I could be stuck here].'"

Hitti found himself in a similar situation to countless others from the Middle East. They live in a country that is overshadowed by war, and they need a way out for their families and themselves. Refugees from all over the world come the U.S. to build a new life. According to the Organization for Economic Cooperation and Development's (OECD) the U.S. accepted 1,183,500 permanent migrants in 2016, which makes the U.S. the top country for legal immigration.

Within the U.S., California receives more refugees than any other state, according to the OECD. In 2017, the Golden State accepted 3,100 refugees, nearly 10 percent of all U.S. refugee admissions. Only Texas comes close to California in terms of refugee admission with 2,825 refugees entering the country in 2017. With so many refugees entering California, many organizations and charities have responded with assistance and care. These organizations help refugee families find jobs, adjust to the culture and most importantly, find a place to live.

One of the most important questions that every refugee must face is where they are going to live. When a refugee leaves behind their home and enters a new country

without knowing where they are going to live, they often struggle to find their feet. Organizations like International Rescue Committee (IRC), Access California and Uplift Charities help refugees with these kinds of decisions. Uplift Charities Case Manager Samir Mohamedy shared how the goal of his organization is to lead refugees and immigrants toward self-sufficiency. This includes helping them with things like groceries, furnishings, spending money and housing. Uplift Charities works with refugees on a case by case basis, and they meet with them personally to determine the state of their financial and social situation.

"Clients never come to us; we go to them," Mohamedy said. "Ideally, wherever they're

Most refugees get placed in temporary housing, such as motels, when first arriving to the United States. However, most of the time, these poor housing conditions last more than most consider to be a "temporary" situation.. (Molly Bolthouse)

living, and that may be an apartment, that may be a hotel or a motel when they call us, that may be their car. In summertime, there are times when we go to the park and that's where we're meeting with them because they don't have a place to stay.

"Initially we pull them out of their jam. That way they can at least take a breather, at least start to think about how they can move forward."

Once Uplift Charities determines the refugee's situation, they can figure out the next steps and how to best assist them. Mohamedy explained how that may involve setting them up in a motel or hotel, or helping pay their rent if they already have a place to live. Another resource available for refugees is room sharing. According to Mohamedy, room sharing is when refugees share an apartment or house. This can also be when a family already living in the U.S. rents out one of their rooms or a secondary property for a much cheaper price. Uplift Charities works with mosques and churches in Orange

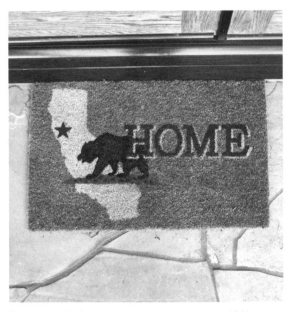

From years of tirelessly working to make ends meet, Hitti has experienced early hair loss despite being in his mid-twenties. (Molly Bolthouse)

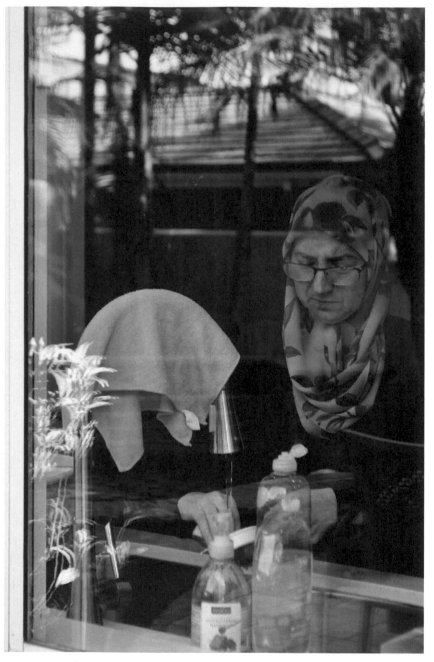

Maria cleans her Huntington Beach home that she purchased with her husband after leaving Syria to pursue safety and opportunity. (Molly Bolthouse)

County to try and connect people who are looking for rooms or tenants.

However, not all refugees entering the country look to resettlement agencies and charitable organization like Uplift Charities for assistance. Refugees can be distrustful of such agencies due to bad experiences with them. For example, in 2017, KPBS San Diego reported that many refugees who received assistance from the IRC in San Diego were left in a vulnerable position. According to the news station, IRC staff were encouraging and helping refugees to lie on rental documents in order to gain housing. This often meant that refugees were encouraged by the IRC to claim that their families were smaller than they actually were. That way they could avoid having to pay for a larger, more expensive apartment. Families who did this were stuck between a rock and a hard place as some of them were forced to vacate their apartments for violating the lease. Although the San Diego agency denied the allegations, their executive director has since resigned and IRC's main office in New York has admitted finding problems with the way the branch has relocated refugees.

Many refugees decided to avoid resettlement agencies and go to family members who are already living in the country. These family members help provide housing and help them adjust to American culture. This is the route that Hitti and his family chose when war broke out in Lebanon.

Maria's shelves are cover in ornate Arabic reading material. Maria and her family are self-proclaimed Muslims and work to promote interfaith relationships between different relgions. (Molly Bolthouse)

Hitti, his mother and his brother were stuck in the U.S. Even when the fighting in Lebanon ceased and the country was safe to return to, Hitti and his family had to decide whether to go back. At this point, Hitti and his brother had started attending school in Riverside. They ultimately decided to stay in the U.S. so they could finish their education. According to Hitti, if they went back to Lebanon they would have been too behind in their schooling and likely would have failed. So, they stayed to live with Hitti's uncle while his father was still stuck in Lebanon. Since Hitti was ahead of his classmates, he graduated high school when he was 16 and started attending college where he studied business.

Many refugees take this route when it comes to housing. Hitti said he was unaware that organizations like Uplift Charities even existed, so he did not go to them for help. Even if he was aware, he said he was too proud and shy to ask for help anyway. Nevertheless, Hitti realized that if he was going to stay, he needed to work to provide for his family. He and his brother found a job selling newspapers door to door. They were paid "under the table," but it was enough to help them start paying for college and saving for a new place to live.

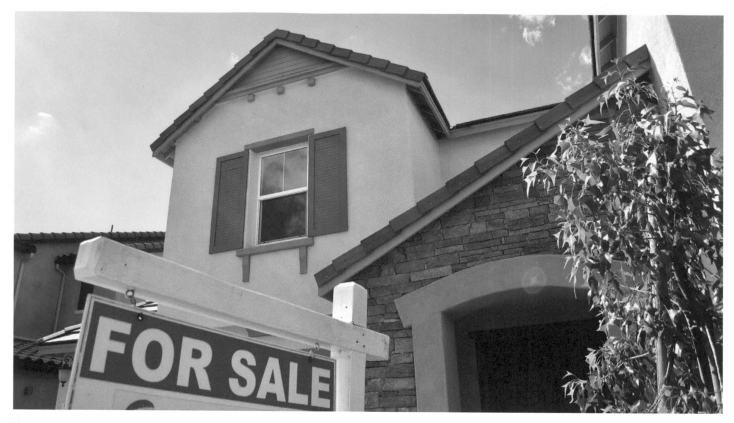

Housing is already incredibly expensive in Southern California, let alone for those who find looking to make a fresh start in a new country. However, refugees like Hitti, have been able to build a new life for themselves through hard work and education. [Molly Bolthouse]

Hitti did not want to live dependent on his uncle forever. When he turned 18, he and his brother applied for their own social security number under the DREAM Act. Once they were approved, they rented an apartment where they could live with their mother and find steady jobs. Hitti started working in sales for a solar panel company. By this time nearly seven years later, his father joined them from Lebanon. Hitti worked as hard as he could to build a new life for himself and his family. By the time his father arrived, Hitti and his brother were stable enough that their parents could retire while their sons looked after them.

According to Mohamedy, many Americans do not realize just how hard refugees are willing to pay their own way. He said that to afford emigrating to the U.S. from the Middle East, a family is has to be upper-middle class to upper class. It can cost $3,000 to $5,000 a person to emigrate to the U.S., Mohamedy said. His estimation is accurate. Supermoney.com estimates that it would cost $3,000 to $4,000 in legal fees for an individual to obtain an H1-B Visa. For a family of four, that cost goes up dramatically. That means they must be well off.

"For them to be middle, upper-middle or upper class, they're either engineers, they're doctors, they're professionals," Mohamedy. "They're very well educated. So, when they do come out here and finally find their way here and get their bearing, that's the kind of job they're looking for.

"They're used to working very hard ... They are trying their very best to pay their own way."

This is what Hitti was doing. He sold newspapers until he could get a business degree which led to an apartment and a stable job. He paid his own way, and that is how he successfully immigrated into the U.S.

Today, Hitti is 24 and identifies more as an American than Lebanese. His main language is now English and he only speaks his now rusty Arabic with his parents and friends from Lebanon. He works in real estate and in sales for a solar panel company, although he has plans to eventually start his own solar panel company. Since he has been living in the same apartment with his parents that he rented when he was 18, he is saving up to buy a house once the market slows down.

Hitti and his family still have not been back to Lebanon, though he would like to visit in the future. He is currently in the process of becoming a U.S. citizen, and wisdom tells him to wait until he becomes a citizen before he strays too far from home. In today's political climate with the Trump administration cracking down the country's immigration policies, California has seen a dramatic drop in the number of refugees entering the country. According to the California Department of Social Services, the number of refugees who entered the state in 2017 was 5,164. In 2018, that number dropped to 383, a 93 percent decrease. This drop is also affecting more than just refugees. The number of people who obtained a Special Immigrant Visa 6,894 in 2017 to 2,258 in 2018, a 67 percent decrease.

Fewer and fewer refugees are being allowed into the country, and Hitti lives in fear that he might be one of the many who have been deported. Because of that fear, he does his best not to travel far from his home in Southern California. Since his arrival from Lebanon, the farthest Hitti has gone from Riverside is to Las Vegas on a trip with his friends. He wants to be certain that he is not going to lose everything he has worked for, the new home he has built. He wants to secure his home before he travels outside of the country because if he leaves before becoming a citizen, he risks not being able to reenter the U.S.

"If I leave, I ruin my entire life," Hitti said. "Everything I've built here is gone and there's nothing you can really do. [I] can come from over there to here to start a life, but [I] can't go from over here to over there. There's nothing for [me] over there."

Attendees at Uplift Charity's food pantry register to receive food boxes. (Alex Brouwer)

ministries and agencies

by Grace Kadiman

"Migrants trust that they will encounter acceptance, solidarity, and help, that they will meet people who will sympathize with the distress and tragedy experienced by others…"
-Pope Francis

The fluorescent-lit hallway at Voice of the Refugees seems deserted and unnaturally silent until a sharp bell rings to signal the start of the 45-minute break from English classes. Suddenly the hallway comes to life with children zooming out of the daycare rooms, finding their place beside their mothers as they watch animated cartoon characters sing in Arabic on a smartphone. Now, random bursts of laughter coming from the makeshift classrooms echo down the hallway. Volunteers and refugees take this short time to exchange stories over cups of coffee and pastries. The strongest bonds are being forged here, in the small moments of vulnerability.

Voice of the Refugees exists at the forefront of the evangelical effort to bring aid to refugees. Three days out of every week, refugee women and children head to Voice of the Refugees in Anaheim to take English classes in a few classrooms set up next to the organization's office space. The children are dropped off at the on-site day care center and the mothers are able to visit them throughout the day during breaks from class. In addition to English classes, Voice of the Refugees helps with furniture donations, citizenship classes, job placement, transportation and translation services.

Alongside Voice of the Refugees, another non-profit organization, World Relief has been involved in helping displaced peoples since 1980. They are one of nine national agencies contracted by the United States Department of State to oversee refugee resettlement. "Our mission," says Glen Peterson, Office Director at World Relief Southern California, "is to empower the global and local church to stand with the vulnerable." World Relief serves

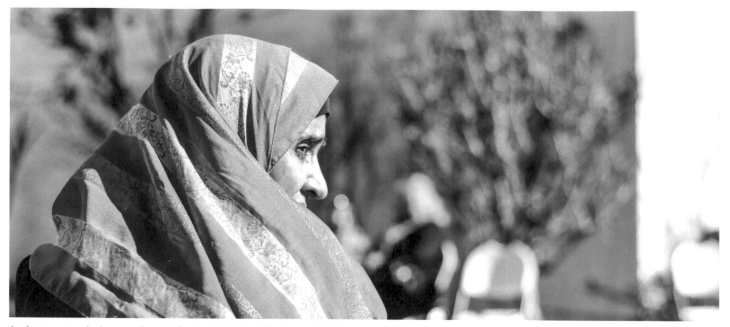

A refugee woman looks on as she waits for the distribution of food at an Uplift Charity food pantry. (Caitlin Gaines)

 Jesus himself was a refugee. We accomodated him as a refugee.

refugees across religious boundaries, even though they are an explicitly Christian organization. Peterson sees the work done by World Relief as strictly refugee aid, not evangelism. They are actively involved in helping refugees with arrival transportation, housing placement, furnishing, and mediating for legal services, such as social security and the DMV.

A Voice of the Refugees spokesperson, who requested to remain anonymous said, "their ideal situation is to be in their home...they feel the crippling effect of a loss of community." Empathizing with the pain these refugees have experienced holistically is fundamental

not only to doing good work, but also in diminishing misconceptions many people have about the community. While referencing the U.S. government's lengthy screening process at the beginning of a refugee's journey to the states, Peterson said, "People who come through the refugee program are the most vetted people on earth."

Many churches throughout the Greater Los Angeles area work with World Relief and Voice of the Refugees to aid displaced persons. Other churches have also taken it upon themselves to design internal ministries to more directly engage with the refugee population in their area. Mariner's Church in Irvine is one of the largest churches in Southern

California and each weekend, three worship services draw thousands of church-goers to the picturesque campus. Named the Africa Director at Mariner's Global Outreach team this past year, Muriu Makumi sees the refugee outreach work they do as both a calling and a command. He explains that engaging in empathy is the ultimate imperative for Christians.

In addition to collaborating with Voice of the Refugees and World Relief to provide relationships and put on events for refugees, Mariner's church has also created a shopping experience at their resource center. In this shopping experience, individuals

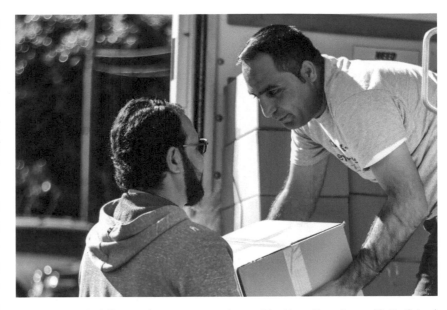
An Uplift Charity volunteer passes out boxes of food to waiting refugees. (Caitlin Gaines)

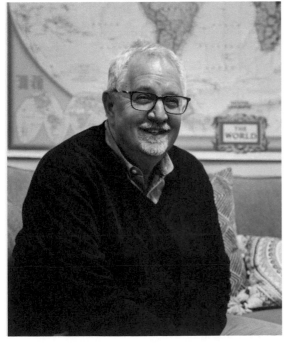
Glen Peterson, Office Director at World Relief Southern explains the significance of the map in his office, which shows all the World Relief locations across the globe. (Alex Brouwer)

can come pick out heavily discounted furniture for their homes, school supplies for their children, or even clothes for an interview. Mariner's aims is to create relationships, not just converts. "People should never be projects," Makumi said. What's most important to his ministry approach is to develop relationships with people of all backgrounds.

Father Mark Hannah from the Archangel Michael Coptic Orthodox Church of resonates with Makumi's perspective on ministering to refugees by viewing compassion and caring for those in need as an imperative. "Being open to the needy, helping others," he said, "this is Christianity 101." Because of their Egyptian origins, many American Coptic Churches find themselves relating to both the Middle Eastern and American culture. This puts them in the position to empathize and care for refugees through a more culturally sensitive lens.

"Jesus himself was a refugee," said Father Hannah, "We accommodated him as a refugee." He went on to explain that the Coptic Church celebrates a feast on June 1st in remembrance of the holy family's three and a half year stay in Egypt as they fled the bloody

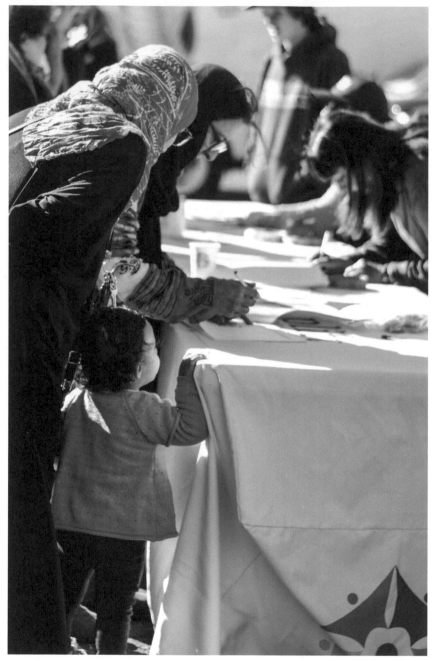

An Uplift volunteer helps a refugee and her daughter sign in to the food pantry. (Caitlin Gaines)

rule of King Herod. Father Bishoy Kamel, a priest at St. Marina Coptic Orthodox Church in Irvine, cited Matthew 25 and said, "caring for a stranger is harboring the Lord Jesus Christ himself." He views Jesus as the perfect role-model for refugee care— both giving and receiving.

As one of the areas in the United States most open to refugees, California does not make the situation harder for organizations but is simply reminding them there is constantly more work to be done. A conversation with Brother Samir about his organization's vision to help underprivileged refugees is vaguely reminiscent to speaking with an individual at the Refugees or World Relief. Plastered on the wall of the Uplift Charity conference room is a slogan, "uplifting people's lives based on Islam followings and teachings."

As a charity, Uplift works towards empowering people who have had the rug pulled out from under them and are in need of temporary support. Their reach goes beyond simple financial support but is instead focused on empowering families to be able to survive independently in an environment where the odds seem to be stacked against them. Uplift Charity has always been in good standing with the community making sure to help many individuals who come to them for help regardless of their faith.

Brother Samir was determined to correct any misconceptions the general American

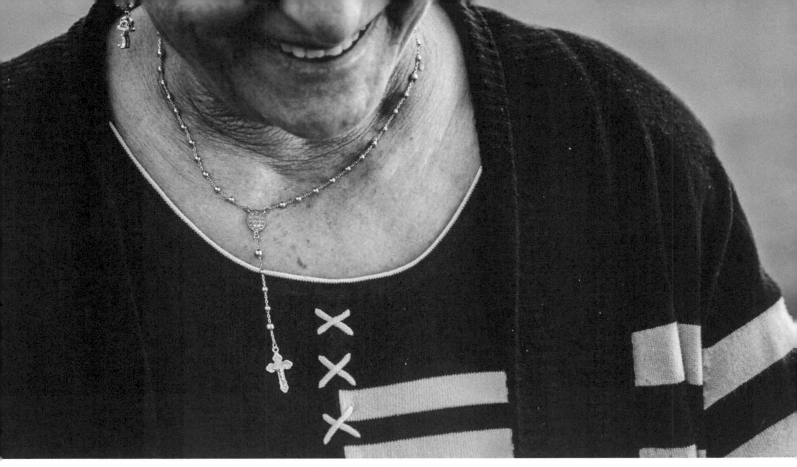

A Coptic refugee woman takes pride in her cross necklace. (Alex Brouwer)

community might have about his faith. "This organization was started by people of Islamic faith who wanted to focus on being generous as taught to them by the Quran," says Brother Samir. Similar to Uplift Charity, Islamic Relief USA is an international non-profit humanitarian organization focused on empowering the lives of families by helping them get on their feet.

Brother Faran from Islamic Relief USA believes there is a teamwork relationship and cooperation between both Christians and Muslims when it comes to the refugee crisis. Brother Faran explains, "what most people do not realize is these refugees are made up of capable and hard-working people who just so happened to be caught in the midst of a war-torn country."He says Islamic Relief's work in the United States is mostly geared towards collaborating with local organizations like Uplift Charity and Access California.

Helping the growing refugee community requires more than the work of one group of people. It appeals to the compassion and kindness of everyone regardless of their religious affiliation or beliefs. As Father Mark Hannah puts it, "whoever is coming, we are helping, regardless of the label that he carries."

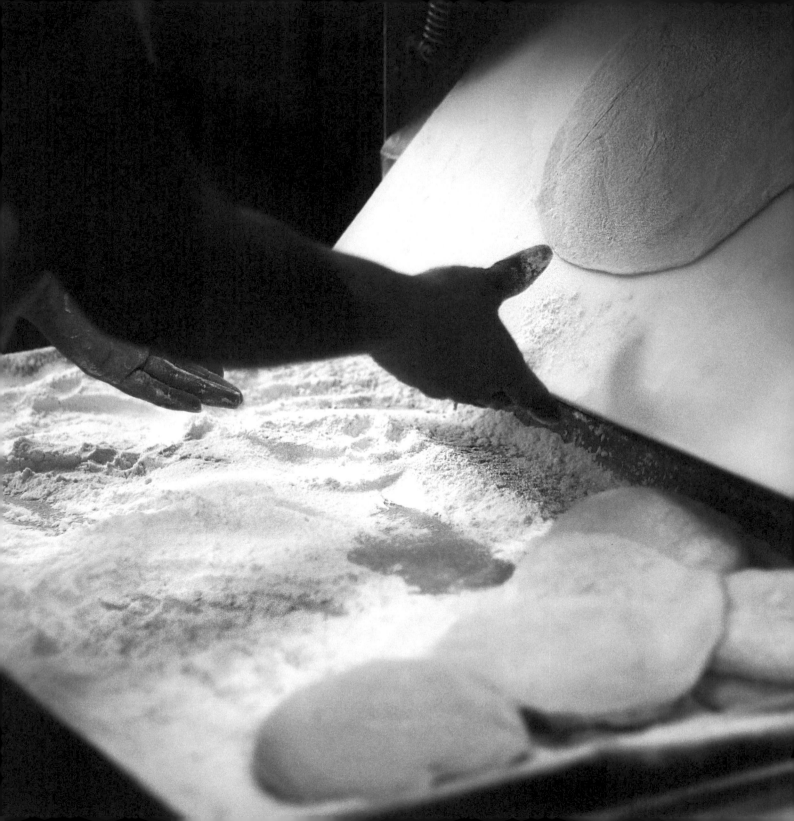

food and hospitality

by Jana Eller

"It's a love language. The love language isn't 'I'm going to feed you,' it's 'I'm gonna host you, be gracious to you, make sure that you're cared for.'"
— Spokesperson from Voice of the Refugees

The heat from the stone oven hits as you step into the shop. With it comes the smell of thyme, oregano, sumac and the steaming Ceylon tea sitting on the counter. Fresh desserts such as baklava, knafeh and cheese boats line the glass shelves below wooden cutouts of proud Lebanese cedars. People chatter in the open kitchen, paying no mind as a tall man with gray hair answers the phone in Arabic. His smile is as warm as the oven.

Mohammad Alam's restaurant and bakery overwhelms the senses and seems to transport customers to Tripoli. Forn Al-Hara has remained a popular business for over 20 years through the growth of the Little Arabia district in Anaheim. Using his grandparents' recipes from Lebanon, locals and tourists get a taste of not only traditional halal cuisine but also of Middle-Eastern hospitality.

"One day I was looking down and I hear people say... 'I'm here at the al-hara.' Al-Hara means neighborhood, and Forna means bakery, so... the 'neighborhood bakery,'" Alam said.

Over 20 years prior to opening the bakery, Alam emigrated from Lebanon in the early '70s to attend English school and earn a degree in architecture from Cal Poly Pomona. Although he intended to go back after graduating, a civil war broke out in Lebanon, postponing his return.

"My dad told me to hold on, just a couple months. The war will be over and you can come back. I said ok. So I hang on. Two months. Six months," Alam said. "So the war went by for 20 years and more."

He stayed in Los Angeles, made a career, got married and had four kids. After he retired, his brother bought the shopping center where he later opened his bakery. As more immigrants

Knafeh is a noodle-like Arab pastry soaked in syrup and layered with cheese, cream, or nuts. Different regions prefer variations of the dessert depending on their location in the Middle East. (Photo: Amelia Mowry)

 # We feel like we're home.

have settled in the surrounding district since Forn Al-Hara opened in the early '90s, the neighborhood has become well-known in the community for offering a taste of home and a safe haven for refugees, asylum seekers and migrants.

"We feel like we're home," he said with another smile.

Although Alam was one of the first people to open up shop in West Anaheim, others soon followed, according to OC Weekly. The increasing influence of Middle-Eastern culture began attracting immigrants from countries like Syria, Egypt and Palestine. More businesses began permeating the air with spices, baked bread, cooked halal meat and hookah. Arabic script and flags popped up, inviting visitors into a whole new world just around the corner from Disneyland. After a social media campaign led by founder and executive director of the Arab American Council Rashad Al-Dabbagh in 2014 to garner interest the area was officially designated as Orange County's third ethnic enclave, "Little Arabia."

"There was hardly any Arabs in the area then, 20 years ago. Little Arabia grew up as the years went by," Alam said.

Food quickly became the cornerstone of the community, as more shops and grocery stories popped up, attracting more immigrants looking for a place to resettle.

"All it took was a couple of restaurants or a bakery and a market and then a family comes, their cousins come, their friends come, and then their cousins or their friends come — it has that effect," a spokesperson at Voice of the Refugees said.

This number of restaurants and bakeries has created much competition. Each restaurant has its own "thing" — whether a certain nationality, eating style or strategic location. When asked his favorite restaurant, Maher Rajab pointed across the courtyard from his own hookah shop to a dine-in Palestinian restaurant — distinctly different from Alam's come-and-go bakery. He then explained that he was biased, however, because he was Palestinian. Everyone has a favorite place based on their home country and family cultural background, he explained.

Across cultures, however, two main components make-up a classic Arab meal: bread and halal meat. Because bread was first domesticated in the Middle-East, according

The "Lebanese Pizza" is one example of how the cross cultural fusion of tradition, innovation, and modernity continues to influence many staple Lebanese dishes today. (Photo: Amelia Mowry)

Man'oushe, a classic flatbread dish, is traditionally made with a common spice called Za'atar. (Photo: Amelia Mowry)

to National Geographic, it has become a staple across the region. One dish includes the man'oushe, made by frying flatbread and covering it with cheese, spices and sometimes meat. Another popular dish includes pita bread. According to Oakland-based Palestinian chef Reem Assil, bread also contains physical healing properties and has become a reclamation in the midst of political controversy and culture clashes.

"Bread is the lifeline, the oral history of my people," Assil said in an interview with KCET. "It's something that is accessible to both the rich and the poor and across cultures; everybody resonates with bread. In even the most remote mountain villages in the Middle East, you'll find a post office and a bakery."

Another key food includes halal meat. In Arabic, "halal" means "permissible," and can be used in reference to anything defined as such by the Qu'ran. However, it is most commonly used in reference to the cutting and preparation of meat. The Qu'ran has strict rules on the preparation of meat to ensure humane treatment to the animals, including a pain-free death, according to the Halal Food

Authority. Many restaurants in the area take steps to ensure their food complies with Qu'ranic standards.

The recipes found in the restaurants and shops often originate in the home country and have been passed down from generation to generation.

"You have thousands of years of these perfected recipes," a spokesperson at Voice of the Refugees said. "You're eating dishes that have been perfected since Abraham's time... Any kind of ancient culture has probably amazing food because of that. You can taste the history in it — it's really rich."

Aside from the food — and despite the competition — Alam's bakery echoes another rich Middle-Eastern tradition: hospitality. In addition to his warm smile, he's known to do small magic tricks for customers and offer free tea and desserts after meals.

Legend has it that Middle-Eastern hospitality stems from the days of nomadic caravans wandering the Arabian desert. People would often travel for hours or days at a time. Thus, when a caravan arrived on someone's doorsteps, the host was obligated to offer food and shelter for up to three days without payment, knowing the travelers had likely not eaten since they began their journeys. Although the means of transportation has vastly changed in the modern world,

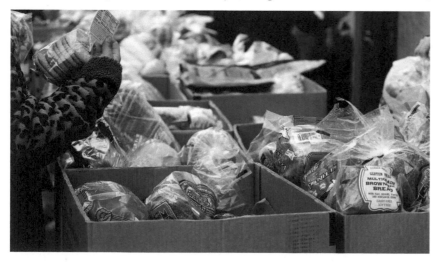
Asylees visit food banks such as the one hosted by Voice of the Refugees in Anaheim. They are not eligible for federally funded benefits until granted full asylum by the U.S. government, relying heavily on organizations such as this one as a resource for food. (Photo: Amelia Mowry)

many immigrant families hold fast to the tradition of providing for the traveler who has traveled across land and sea. As a result, meals among Middle-Eastern families do not entail a simple fast food run. Rather, it insists on a two-hour visit with friends and family over a large home-cooked meal.

"There's a sense of honor and shame in the amount of food you're able to prepare... I think the more work that goes into it the better the sense of you're honoring them, you're showing them that you care for them. You care that it looks good and you want them to be enjoying that experience," a spokesperson at Voice of the Refugees said.

The ability to serve and host others is among the few tangible items immigrants, refugees and asylum seekers carry with them during their journeys. Thus, they often maintain these traditions and meals to continue recreating a place of refuge in an unfamiliar place.

"Their ideal is to be in the old city of Damascus, to be in Cairo, to be in Baghdad or Mosul [with] their family business, their family and friends they'd visit on the weekends — they didn't want to lose that. They didn't want to exchange that for America. [But] now they're here and they're trying to make the best of it," a spokesperson at Voice of the Refugees said.

While some well-established families have made a life for themselves through businesses, others depend on food stamps and distributions to provide for their family

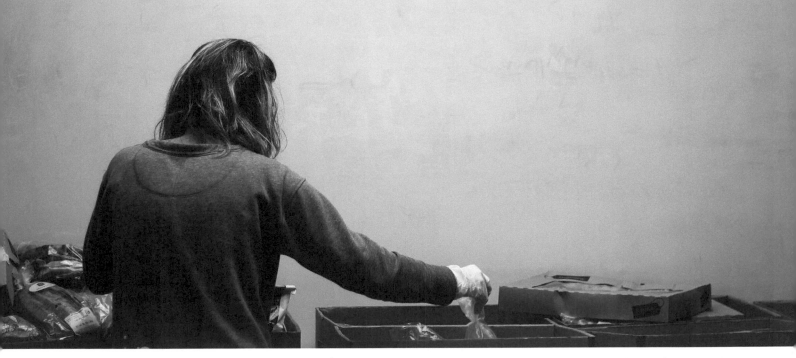

Voice of the Refugees volunteers meet every Monday afternoon to sort and package bags of donated food to be handed out to families; they also provide transportation to and from the event for those without access. (Photo: Amelia Mowry)

meals. Suzanne Baker, AmeriCorps Program Director at Access California, explains how one group of immigrants often struggle to make ends meet.

"A lot of immigrants, they come here on a visa and then they stay. So they are not eligible for any benefits from the government. They are called asylees," Baker said.

In response, several organizations, including Voice of the Refugees, offer food distribution programs. Mike Long, a pastor at Crescent Southern Baptist Church where Voice of the Refugees is housed, explains how asylees rely the most on food pantries for provisions. Because most of the food comes from American chains and may seem quality by American standards, they may not always provide food that complies to Qu'ran or traditional Arab standards. Although the recipients may need to be more reserved in how they use the food, this does not hinder their desire to host and honor guests.

For many immigrants, culture and family take precedence. As more and more immigrants continue flocking to Little Arabia, the area continues to grow and provide a home away from home — a place to begin rebuilding lives and connecting with a new community over familiar traditions and tastes.

Music, film, spoken word and other various forms of entertainment
are an integral part of Middle Eastern culture and the way its
people express both its sorrows and joys. (Kyle Kuhne)

music and entertainment

by Pierce Singgih

> "We're so covered in political dust that constantly overshadows our culture and humanity because the governments are so problematic and controversial. We're always in the headlines...our culture gets buried."
>
> - Sara Zandieh, director of "Simple Wedding"

Sara Zandieh was born in Iran, but immigrated with her family to America in 1986 when she was five, at the height of the Iran-Iraq war. Growing up in America, she always knew she was destined for storytelling, graduating with an MFA in film directing and writing from Columbia University. After directing a few short films, she eventually made her feature film debut, "Simple Wedding," which follows an Iranian-American lawyer who finds herself caught in a battle between the traditional values her parents hold and the progressive ideologies she truly believes in.

While "Simple Wedding," which first premiered at the Los Angeles Film Festival in 2018, is certainly full of endearing messages about familial love, cross-cultural dating and the difficulties of personal culture wars, it also takes steps to feature an Iranian-American family for who they truly are—a normal, loving family. For Zandieh, the unfair politicization of Middle Eastern people was part of the fuel that drove her to make her first film.

"Simple Wedding" doesn't follow politics or the disagreements between certain governments. Rather, it showcases an everyday family and the drama and humor that surround their unique situation. Zandieh used her film to properly represent a people group that is so often misrepresented.

By representing her experiences, Zandieh is introducing more diversity into mainstream culture. By doing so, she hopes she can expand Americans' understanding of different people and different culture.

"Diversity and multiculturalism is such a positive bonus in American culture," Zandieh said.

At its core, entertainment is used for enjoyment. Some people go to the movies to have fun, some listen to music to escape from the world and some consume art for serenity. One can find these forms of entertainment within many cultures, but they are certainly not all the same. With these diverse differences in worldwide culture, entertainment eventually adapts if it makes its way to America, presenting new mixtures into American multiculturalism, according to the Daedalus Journal of the American Arts and Sciences. From filmmakers to musicians, this chapter highlights different voices of Middle Eastern entertainment in America, demonstrating how an intersection of culture can create beauty that both cathartic and creative, using unique sights and sounds that bring cultures together.

With her debut film Iranian-American filmmaker Sara Zandieh salvages her culture from the depths of the American film industry and brings it to light with an earnest and unique lens. (Kyle Kohner)

Founder of Zawyiya Perspective, Abudllah Haroon is an ambassador of art from every walk of human life. (Kyle Kohner)

Sandwiched between State Route 55 and Red Hill Avenue in Santa Ana, Muslim-based organization Zawiya Perspective lies hidden within an industrial park containing myriad aerospace, biomedical and automotive engineering offices. Zawiya Perspective seeks to unite people from various cultures, races and religions in order to live in community with each other. Zawiya Perspective means "corner perspective" in Arabic and was founded by Abdullah Haroon, a Pakistani-American who moved to America when he was three. Haroon is a data scientist by trade, but is passionate about the ways Middle Eastern people and Muslims can connect with modern American culture.

Zawiya Perspective hosts a quarterly event called Lyrical Nourishment, a performance night open to anyone to sing, rap or perform spoken word and poetry. Before entering Zawiya Perspective, you are first asked to place your shoes on racks and are then greeted by hosts with a donation box and a long table arranged with Middle Eastern tea and snacks. Walking into the building, your eyes are immediately drawn to large typography in Arabic and English that says "Life" and "Teach Peace" splattered on the walls. You are not only

By way of the arts, Zawiyah Perspective's Lyrical Nourishment, located in Santa Ana, Calif., aims to unite people from different backgrounds and teach peace. (Kyle Kohner)

"It's important to get out the inner artist in everyone.

mct by men and women from Middle Eastern backgrounds wearing traditional head scarves and clothing, but also those not wearing traditional clothing, young, Caucasian college students and an orthodox Rabbi wearing a long black robe and a kippah.

Lyrical Nourishment allows both Muslims and Christians, Middle Eastern immigrants and homegrown Americans to express themselves creatively. Sarrahh Alktub is half-Lebanese and half-Syrian. Having been raised in Southern California as a Muslim, she finds Zawiya Perspective to be the perfect opportunity for her to express herself in ways that might be condemned or judged in other circles.

"You can't go to a mosque, or a church or a temple by any means and be like, 'Hi guys, I'm going to perform my dark poetry.' [They would] be like, 'No, sorry this isn't that type of space.' I love the fact that we can play music here," Alktub said. "That we can perform our spoken word and that it's very open and encouraging to perform and say what you want to say."

Alktub's poetry is cathartic. They act as a release for her to express her emotions in front of people who love her and accept her. The same can be said for Usman Khan, a Pakistani-raised American who believes music and entertainment can teach you about the various complexities of the human soul.

"It's a great space to have," Khan said. "It's important to get out the inner artist in everyone. Everyone has some inclination to do art in a certain way... It's a good way to understand common themes and human themes [of] love, compassion, virtue, despite your traditional religious background might be."

73

Aside from being a manager at a local hookah shop, AWNI, is a burgeoning force in the hip-hop world, both in the Middle East and Southern California. (Kyle Kohner)

Just as many patrons of Lyrical Nourishment may want to connect with their inner roots or express themselves creatively, Awni Othman, 21, uses rap and hip-hop to express himself through musical storytelling. Othman moved with his family to America from Jordan when he was five. Known by his stage name Awni, Othman developed his love for hip-hop when he was in high school and to this point he has released two full-length albums, an EP, has thousands of streams on Spotify and holds a substantial social media following.

While Othman's music has many markings of modern hip-hop songs, he also seeks to bring diverse and unique sounds into his music.

"I've had a few beats where I had a producer sample a sound from an old Middle Eastern record," Othman said. "There's a lot of really good Middle Eastern records if you hear them. They're not hip-hop, but the instruments being played [are] all natural. Nothing's being made in Pro-Tools or Logic or Fruity Loops [where] you can make the beats after."

This includes using the oud, an instrument similar to the guitar which is prominent in traditional Middle Eastern music. According to Arab Instruments, the oud is known as the "king of instruments," deriving its name from the Arabic word for wood. It features a short, fretless neck and a wide hollow body which creates a very rich guitar sound. Othman also uses a tableh, a traditional drum, in his beats. While these sounds are not present in all of his songs, the infusion of these traditional elements with modern music allows creativity and uniqueness to collide into a symphony of multiculturalism.

With music that is multicultural, Othman's fanbase is also diverse, coming from America and the Middle East, even though he raps in English.

"It's not like, 'Oh he's Middle Eastern, all his fans are going to be Middle Eastern,'" Othman said. "I had a show in Anaheim in November...and there was about 280 maybe 250 people and it was a mix of everything. You see Middle Easterns, you see latinos, you see white people, you see black people, you see everything, Asians—every race you could think of was there. I love seeing that and I love seeing people interact with my music."

While Othman may not cater his music directly to one part of the world, another rapper—and frequent collaborator—is trending in Jordan and the Middle East. Arab Falcon, whose real name is Othman Sharabi, 23, lived his entire life in Jordan before moving to

A brazen personality, Arab Falcon is a Jordanian-born rapper trying to mend the cultural void between Southern California and his homeland. (Kyle Kohner)

California in 2014. After moving to America, Sharabi realized he was missing out on the unfiltered, creative nature of hip-hop and rap. While Sharabi is not the first rapper in Jordan, he considers himself the pioneer of trap music—a subgenre of hip-hop characterized by its bold and frenetic usage of hi-hats.

"If you want to compare Tupac for the old generation and the Migos for this generation, well, I'm the new Migos. That's exactly what I kind of brought to the Middle East," Sharabi said.

Now, Sharabi has nearly 7 million views on YouTube and over 85 thousand followers on Instagram. He believes his music can help fill the gap of culture Jordanians have been missing out on.

"I [rap] in Arabic, but it's not some Arab s***," Sharabi said. "[It's] maybe [a] new generation for Arabs... You could say I'm literally a translator... If I listen to a Drake song in English and I like the flow, I can do the same s*** in Arabic."

For all these musicians and entertainers, representing diversity is more than pushing an agenda. They happen to create unique sounds, tell new stories or introduce new music to new people because multiculturalism is one with their nature. Music and entertainment do more than entertain. They open a vessels of opportunity for diversity to further itself into culture and into the world.

"I just happen to be hitting the diversity button, but it's literally just my world," Zandieh said.

photo series: food as culture

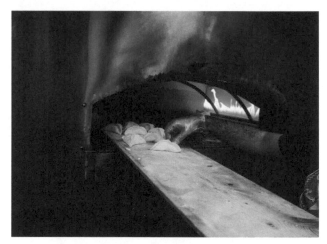

Top Left: Nader Hamda boxes a to-go order of freshly baked Fatayer and freshly made bread, seasoned with Za'atar for a customer. (Cooper Dowd)

Middle Left: Nader Hamda moves handmade meat and cheese Fatayer from the wooden cutting board to the industrial sized pizza oven. Forn Al Hara sells a variety of traditional Middle Eastern baked goods. (Cooper Dowd)

Bottom Left: Knafeh, a traditional Palestinian desert, is topped with a sweet layer of simple syrup and pistachios on top of a savory layer of melted cheese. (Kathy Baik)

Far Right: Spinach-filled Fatayer set out to cool for future customers. (Cooper Dowd)

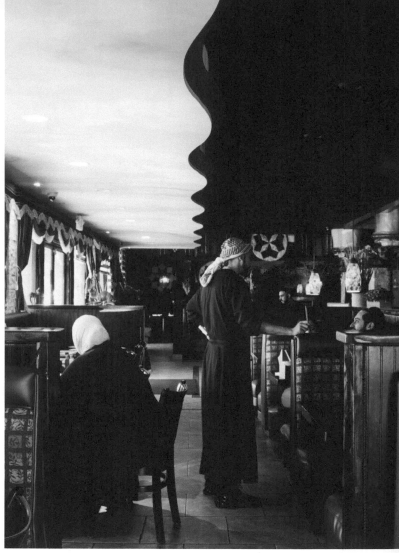

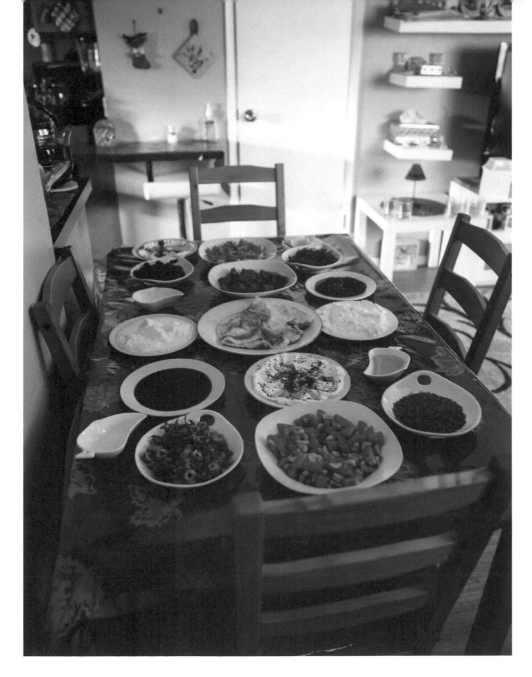

Far Left: Seasoned with Cardamom, Turkish Coffee packs a huge punch that will wake up any caffeine addict. Abusir serves it in a traditional Turkish cup and pours it from a ladle that also acts as the kettle. (Kathy Baik)

Middle: Dessert Moon Cafe, a restaurant that serves traditional Syrian food, makes Syrian customers feel at home with its familiar interior and home-style cooked foods. (Kathy Baik)

Right: Shevin, a Kurdish refugee woman from Syria, makes a traditional Mediterranean breakfast complete with Iraqi bread, homemade yogurt, date molasses, and other dressings as a sign of hospitality and preservation of a sense of home. (Hannah Clark)

Nader Hamda moves handmade meat and cheese Fatayer from the wooden cutting board to the industrial sized pizza oven. Forn Al Hara sells a variety of traditional Middle Eastern baked goods. (Cooper Dowd)

Loyal customers enjoy traditional Turkish food in Al Sannabel Cafe in Little Arabia, CA as the interior design brings them back home to Turkey. (Kathy Baik)

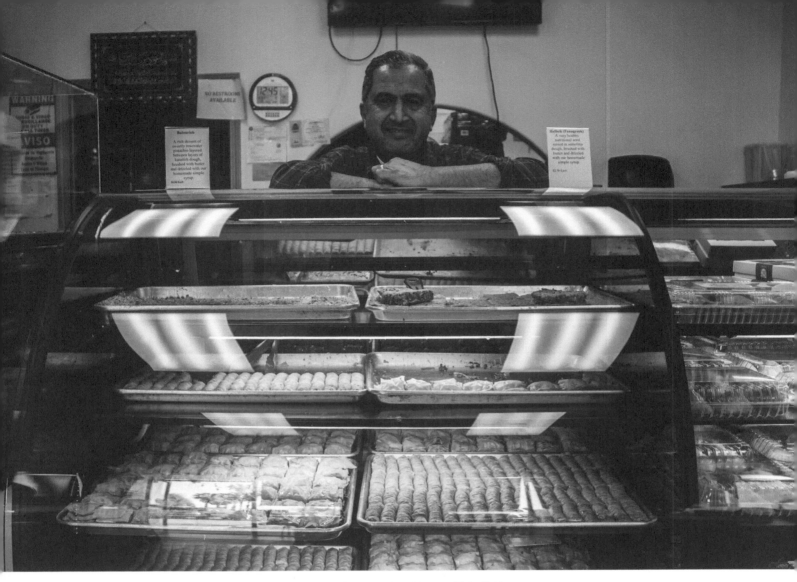

Asem Abusir, the owner of Knafeh Cafe, takes pride in his locally famous cafe and its beloved deserts. (Kathy Baik)

part II

yesterday, looking back

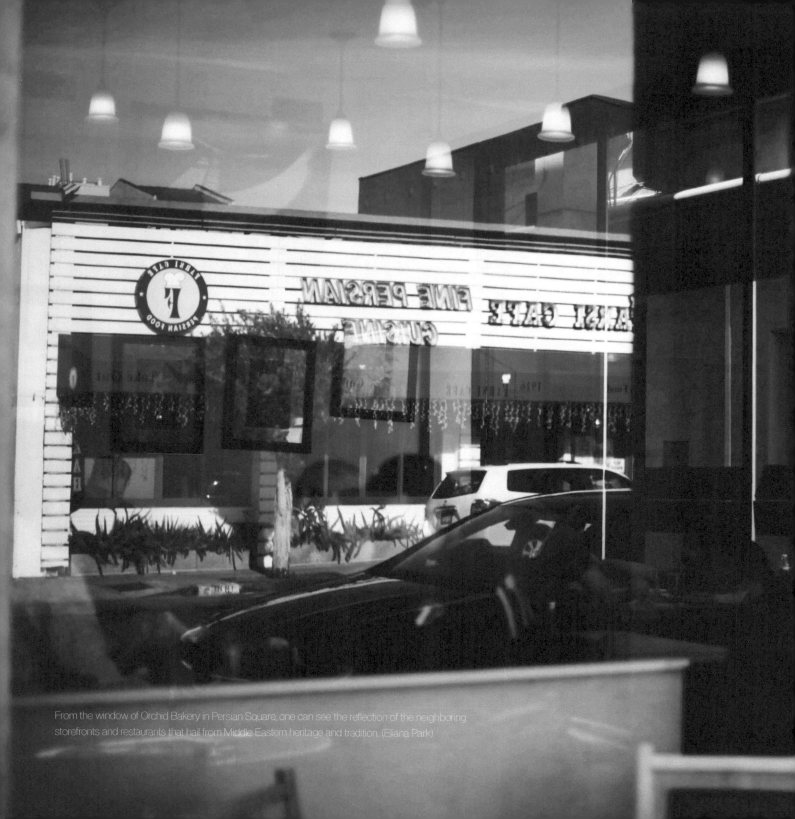

From the window of Orchid Bakery in Persian Square, one can see the reflection of the neighboring storefronts and restaurants that hail from Middle Eastern heritage and tradition. (Eliana Park)

history of refugee resettlement in los angeles

by Gabriel Plendcio and Colleen Sammons

"I'm lucky now to have friends who don't discriminate against me or my religion, and who allow me to express myself the way I want to."
-Shaheer Rahman

"Terrorist," is what rung in Shaheer's ears one morning in elementary school as he found himself the subject of an unexpected discriminatory joke. He was caught off guard as someone he thought was his friend made untrue remarks about him. Shaheer stood up for himself, telling the boy that he didn't think that was funny. However, the joke continued, and the phrase "terrorist" became a nickname for Shaheer. His grades began to crumble and he isolated himself, but the last straw was when another student accused him of betraying his home country. Filled with anger and frustration, Shaheer looked to his teachers for help. With the teachers' concern and support, his school situation began to improve, and the bullying stopped. Shaheer became a straight A student as he made his way to high school. When asked about this incident years later, he offered some advice and appreciation for the community he now has in America. He encourages people to invest in relationships that will help them thrive, rather than ones that are discriminatory. He tells readers to not settle in a relationship in which they feel confined. When it comes to the friendships and community he has established in America, he states, "I'm lucky now to have friends who don't discriminate against me or my religion, and who allow me to express myself the way I want to."[1]

It is safe to assume that based on Shaheer's self-identification as a Muslim, he or his family may find a community among others with a similar faith. Community is an important

aspect for any religion as a whole, as well as for individual growth. As we look at the broader perspective of this book, we want to tell the stories and historical accounts of specific religious communities' growth in Southern California. People are curious as to why there has been an influx of resettlement by Coptic Christian and Muslim refugees. This chapter plans to break apart and discuss the relationships between the words "refugee" and "asylum seeker" while offering a background of refugee resettlement in America to strengthen the context on the history of Coptic Christian and Muslim refugees' growth in communities specific to the Los Angeles area.

Who is a refugee?

The words refugee and asylum seeker are often used interchangeably to describe groups of people, but what do they truly mean? A lot of the differences boil down to policy. When people are forced out of their country for reasons due to race, religion, nationality, membership in a particular social group or political opinion, they fall into the category of asylum seeker or refugee. The Department of Homeland Security defines a refugee as "a person outside his or her country of nationality who is unable or unwilling to return to his or her country of nationality because of persecution or a well-founded fear of persecution on account of race, religion, nationality, membership in a particular social group, or political opinion."[2] These are people whose struggles have been recognized by the government. In contrast, an asylum seeker is defined as "someone who is seeking international protection from dangers in his or her home country, but whose claim for refugee status hasn't been determined legally."[3] The distinctions between refugee

and asylum seeker are important in the context of the resettlement of Middle Eastern refugees in Los Angeles. These are people living in danger in their home countries, who have been recognized by the United States government according to the criteria set forth and are able to seek a new start.

Background of Resettlement:

Those living in danger or fear are simply looking for a place to live where they don't have to look over their shoulder in fear of who might see them. When refugees are not able to return to their home country, resettlement in a willing country is usually the last option. In the United States, the president has authority over resettlement. After consulting with Congress, the president establishes processing priorities for the specific requirements for refugees coming in and a target number of refugees the country wants to resettle. [3] Resettlement within the United States dates back to the early 1950s, when Congress enacted its first refugee legislation, the Immigration and Nationality Act of 1952. It was not until Congress passed the Refugee Act of 1980 that the U.S. fully began providing refuge and new beginnings for those seeking help.[4] Although the opportunity is there for refugees to seek peace in America, the process to gain protection is rigorous and long. After selection there are multiple screenings, interviews, security checks, medical checks and travel arrangements that make the process on average of about two years. Once one seeking a haven makes it into the U.S., there are nine national U.S. refugee resettlement agencies with over 350 offices that assist newly arrived refugees to settle within local communities. There are options to resettle in specific areas within the United States, but

many religious groups have chosen to form their communities in Los Angeles. One such group is the Coptic Orthodox Church.

Coptic Christian Refugee Resettlement in Los Angeles

Shaheer Rahman found value in the friendships and community that did not discriminate against him in America. Coptic Christians value community highly because of their faith, which is a branch of the Orthodox Church. According to ancient texts, Christianity was introduced to Egypt through the ministry of Saint Mark in Alexandria. The Christian faith puts a huge emphasis on the significance of community, as seen in several New Testament texts. "Christian people of Egypt," or "ni rem en kīmi en khristianos" in Coptic, is what Copts called themselves. However, unlike Christianity in the U.S., Coptic Christians in Egypt are the largest religious minority. As a result, the Muslim majority tends to persecute them. Facing mass persecution and hate crimes, such as the 2017 bombing of two Coptic churches in Alexandria that left 45 people dead, Copts looked for a place to turn, one that would grant them safety and freedom of expression. The United States offered a place of refuge and a further establishment of their religion. As California was growing increasingly diverse during the aftermath of World War II, the first Copts settled in Southern California in the mid-1950s.[5] Copts centered their lives around their religion and after coming to Southern California in the mid-1950s, they would eventually open the first Coptic Orthodox Church in Los Angeles within 20 years of their settlement.[6] The formation of Coptic communities once established in Alexandria by Saint Mark began to sprout up in Los Angeles as well.

Muslim Refugee Resettlement in Los Angeles

Islam is the fastest growing religion in the world. Muslims hold six major beliefs and have five pillars of practice to follow. There are two major groups of Muslims—the Sunnis and the Shiites—who hold similar beliefs but disagree about the prophet Muhammad's rightful successor. Muslims constitute the majority religion in many countries but still face persecution and have had to become refugees. Many of these Muslims have found themselves in Los Angeles seeking a new life. These refugees have created a strong culture in LA and have made coming to America more comfortable for other fleeing Muslims. Family and faith are important to the Muslim people and the freedom to focus on these values in Los Angeles has made it an attractive destination.

Being Muslim in Los Angeles

When Muslims leave their country in fear, seeking to find a haven, they often land in Los Angeles because of the growing, supportive Muslim community that has emerged here. As of 2010 a survey estimated there were 120,868 Muslims living in Los Angeles and surrounding counties.[7] This estimate has undoubtedly been surpassed today. Mosques are key components to the Muslim faith and are an essential factor for settling. These places offer a sense of home that can make the transition easier. There are a variety of mosques in Los Angeles that can meet the needs of different Muslims. Along with the mosques, cultural centers also exist to support and provide resources. Neighborhoods of Muslims have developed to provide safe havens and work for each other.

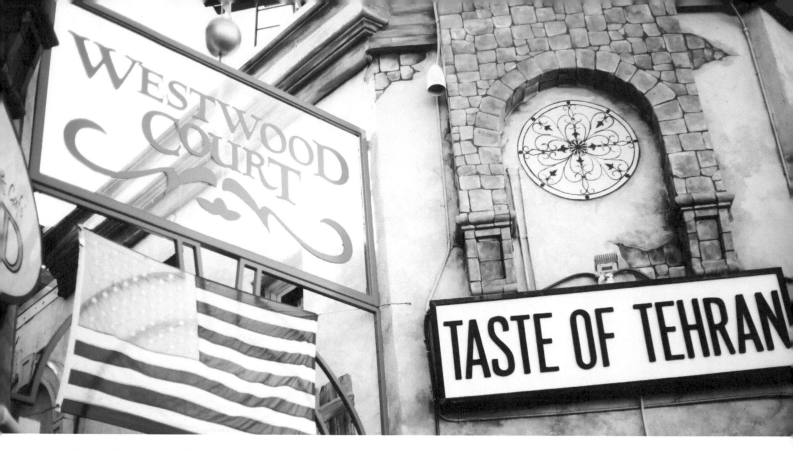

Westwood Court in Persian Square, or more known as Tehrangeles, is a block dedicated to an exclusively-Middle Eastern community in west Los Angeles. (Eliana Park)

Struggles of Muslim Resettlement

Since Muslims have come to America in large groups, they are able to form tight-knit communities here, but this impact has not always been positive. Due to tensions brought over from home countries, different groups often clash. Due to political tension in their country of origin, Persian Muslims are known to experience conflict. In an interview published in "Iranegles: Iranians in Los Angeles," a book that documents the lives of Iranian refugees, practicing Muslim, Pari, provides this explanation on the political situation, "It is [the tension in the Persian community is] because of the political situation, the conflict between the regime in Iran and the people here".[8] This helps explain the tension that many feel when moving to the United States despite the support that is also here. This is only one example of how Muslims have faced struggles.

September 11, 2001 is a day that will forever be remembered in the hearts of all Americans, but is often felt in a different way by Muslims. After the attack, many Muslims attempted to distance themselves from Islam for the fear of being targeted in hate crimes. "9/11 has amplified the fears, hostility and suspicion toward Muslims as a national security threat".[9] This is seen through more security in Muslim communities. Muslims are often weary of

visitors of their communities, for fear that they may have alternative motives. This has been seen through FBI actions. The Federal Bureau of Investigation plans to continue using undercover informants to detect terrorist plots—programs that disproportionately target Muslims[10] These have made it very difficult for Muslims to trust anyone outside of their community due to fear of malintent. Those suspicious of Muslims have made it harder for refugees to resettle as well.

Final Thoughts

Los Angeles is seen as a destination of new beginnings. Some desire the coastal area and wonderful weather, while others seek Hollywood fame, but when you are fleeing your country in fear of your life, Los Angeles becomes so much more. For many refugee groups including Muslims, Coptic Christians and Jews, Los Angeles has become home. It has a diverse population, and its many resources, communities and worship centers bring a sense of familiarity and hope to those who need it most.

Taste of Tehran is one of the two restaurants in Westwood Court, where customers can sit and enjoy a bite to eat. (Eliana Park)

history of muslim refugee resettlement in orange county

by Whitney Siefken and Daniel Su

"I have travelled twice before in my life, but the last two times we travelled we were escaping. This time I am going to live a new life."
-Nine-year-old Syrian refugee, Mahmound[1]

There have been three million refugees who have resettled in the United States since Congress passed the Refugee Act of 1980. California is the top resettlement state, and many Muslim refugees relocate to sunny Orange County.[2] Why have Muslim refugees from the Middle East chosen to relocate to California, and specifically Orange County? What does it mean for them to resettle? Why move from a place they have always known to one they have never even seen to live among people who do not understand them? These are the questions that will be explored in this chapter, as well as bringing understanding to experiences which many may not be aware of.

A family of 17, the Ezzeddins consist of three generations: Mahmoud and his wife, their three grown children with their spouses, and the children of the three younger couples.[3] Mahmoud, as the patriarch, chose to come to the United States after violence caused by the civil war in Syria, which started in 2011, destroyed their house. "My house fell down. It fell down. In one moment you lost everything...everything;" says Mahmoud as he recounts the fateful day that changed the lives of his whole family. The Ezzeddins had been lucky enough to apply to be allowed into the country before the travel ban went into effect. Once into the country, they were forced to move from one temporary housing situation to the next until they met their sponsor. Debby Darling was a Christian career woman with a serious heart

for helping others. Upon learning the extent of their situation, she wasted no time in doing whatever she could to help them; yet she found resistance from both institutions and her friends when she tried to involve others. Darling had to discover the hard way that it is still a common response for people to be suspicious of foreigners, especially those from the Middle East.[4]

The Ezzeddins do not really care if they are perceived differently; all they care about is raising their children safely. America is much safer than the unpredictable and war-torn climate of their home country, yet this also means the young ones will not have any recollection of the Syria in which their parents grew up. Mahmoud misses the intimate familiarity of the neighbors he left back in his hometown while Amjad, Mahmoud's son and father of 5 year old Miriam, is trying to be optimistic about his daughter's future. Although she will not be able to grow up the way he did, and might lose touch with some of her heritage, she has been exposed to more cultures and languages than he had at her age. This will hopefully be an advantage for her when she grows up. The Ezzeddins are unsure how they will find consistent work to make a living, as their former careers as furniture embellishers are now closed to them. Darling is hopeful that her new friends will be able to thrive in America, however, and that they will come to experience it as she has.[5] The struggles that the Ezzeddin family has to go through are very typical of the thousands of refugee families who have left their countries of birth to escape domestic unrest and come to the United States.

The Path of the Journey

Middle Eastern refugees have been immigrating to the United States in the wake of major world events since 1870. The first of these events was the destabilization of the Ottoman Empire. The second was the establishment of the state of Israel in 1948, which initiated a series of conflicts in the Middle East. However, refugees did not come in significant numbers until the passing of the Immigration and Nationality Act of 1965, which relieved many previous, highly restrictive immigration laws. One of these was the 1924 Immigration Act, which used a quota system to limit the number of migrants allowed into the United States.[6] Since that time, the Middle Eastern population in the United States has grown exponentially and continues to increase today. The rate has dropped within the past few years due to President Trump's Executive Order 13769. This order completely denied asylum for Syrian refugees, suspended multiple forms of visas for a period of time and seriously limited the number of immigrants, no matter their country of origin, from entering the country.[7]

Why They Left

There are several push factors that have brought so many refugees to Orange County. Push factors are particular issues or causes which would force people to leave their home country. These factors range from economic insecurity to conflict. Good job opportunities are often scarce, and as a result, many people come to America on an employment visa before making enough money to bring their families over.[8] Others flee because the violence has become unbearable and life-threatening. Because of the 1967 Arab-Israeli War, hundreds of thousands

of Palestinians fled to the United States. The 1975 Lebanese Civil War also caused thousands of Lebanese to seek asylum. The Iraq War devastated the region around Iraq, causing many to seek refuge in the United States. The Syrian Civil War, which is still ongoing, has forced millions of Syrians to flee their lands.[9] Everything from economic inadequacy to civil unrest to all-out war have been reasons to leave—or push factors—which have contributed to the unavoidable and involuntary relocations of entire communities.[10]

Incoming Muslim Refugees

When Muslim refugees leave their country and come to the United States, many factors are involved in the resettlement process. Not only is travel an element to consider, but U.S. policies have a great impact on immigration for refugees. In the recent history of immigration laws in the United States, policies have changed rapidly. These fluctuations make it hard for anyone entering the country. In spite of this, many Orange County cities are willing to take steps to make refugees feel more welcomed into the community once they arrive. This can be seen in spite of the recent "travel ban."

On January 27th 2017, President Donald Trump signed Executive Order 13769, otherwise known as the "travel ban." This presidential order suspended the U.S. Refugee Admissions Program, banned Syrian refugees from entering the country (capping accepted refugees at 50,000), and suspended visas for ninety days for anyone from seven other Muslim-majority countries. These included Iraq, Syria, Iran, Libya, Somalia, Sudan and Yemen. This ban was part of the President's plan to, as he said, stop groups of radical terrorists from entering the U.S. This order also gave priority to "religious minorities facing persecution in their countries."[11] After many protests from groups such as the Council on American Islamic Relations, the American Civil Liberties Union and the Muslim Public Affairs Council, the U.S. Supreme Court allowed the travel ban to take effect with new guidelines.[12] The travel ban continues to affect Muslim refugees seeking protection in the U.S. Although the history of Middle Eastern admittance into the U.S. seems to be confusing, ever-changing, and to some, infuriating, the refugees who are coming find haven and acceptance in many U.S. states, including California.[13]

The United States Refugee Admissions Program (USRAP), which was established in 1975, plays the most significant role in controlling the number of refugees let into the country. The president himself establishes the country's admission numbers each fiscal year.[14] The USRAP deals with many different U.S. federal and state departments who are connected to handling immigration. According to the USRAP, to be considered a refugee, those seeking resettlement must first receive a referral. After the referral, and application must be submitted and an interview must take place. These will determine whether or not the person can be eligible for resettlement. If they are approved, many different steps are taken, such as a health screening, cultural orientation and medical/cash assistance once they arrive. After they are approved as a refugee, they have to apply for a green card one year after arriving in the U.S. Clearly, these steps are extensive, and can take a lot of time and money. Ultimately, the refugees that are granted resettlement will be moved to a U.S. state, such as California.

Little Arabia

History and Milestones

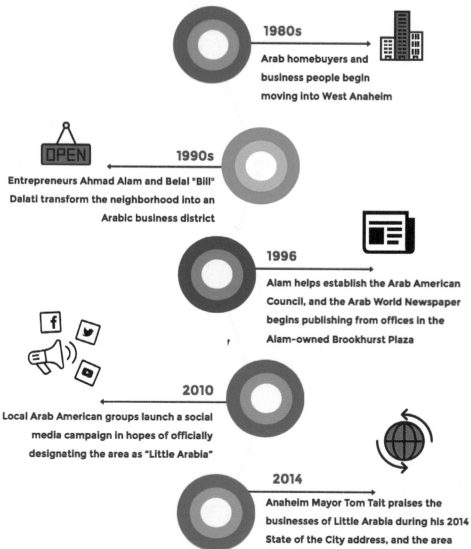

1980s

Arab homebuyers and business people begin moving into West Anaheim

1990s

Entrepreneurs Ahmad Alam and Belal "Bill" Dalati transform the neighborhood into an Arabic business district

1996

Alam helps establish the Arab American Council, and the Arab World Newspaper begins publishing from offices in the Alam-owned Brookhurst Plaza

2010

Local Arab American groups launch a social media campaign in hopes of officially designating the area as "Little Arabia"

2014

Anaheim Mayor Tom Tait praises the businesses of Little Arabia during his 2014 State of the City address, and the area receives nationwide media coverage

California continues to be have one of the largest refugee populations in the nation.[15] In leaving their country, many Muslim refugees look to California for acceptance. According to a 2017 article titled "Which California cities have refugees resettled in? Nearly all of them," in the Sacramento Bee, author Phillip Reese claims: "California has welcomed about 112,000 refugees in the last fifteen years, according to the State Department. They have resettled in more than 440 California cities and unincorporated communities."[16]

Why Orange County?

Many of the cities in which refugees resettle in are located within Orange County, and there are a variety of reasons why. One reason is that many of the nonprofit organizations that specifically help refugees integrate and thrive in their new environments are located in Orange County. These include Voice of Refugees, UPLIFT Charity, and World Relief. Another reason is that many Orange County cities have made plans to support and accept refugees. Additionally, the settled Middle Eastern communities already established in O.C. offer a taste of home for the new refugees entering the region. These aspects help to attract refugees to countless Orange County cities.

Anaheim, for instance, is one Orange County city that may look appealing for incoming Middle Eastern refugees. In October of 2017, it was established as a "welcoming city."[17] This means that as a city, Anaheim will work hard to accept refugees and integrate them into their communities. It can be assumed that the "welcoming city" title was in response to Trump's travel ban, as this title was made official only six months after Executive Order 13769. The news site Voice of Orange County states that "40% of Anaheim citizens are either foreign born or children of foreign born individuals."[18] This can be a leading factor in Anaheim deciding to welcome non-citizens, as almost half of their population has a connection to immigration. They seek to create "open and engaging communities for residents of all backgrounds."[19] In becoming a welcoming city, Anaheim hopes to unite their whole community by promoting inclusion. As a result of Orange County cities making an effort to welcome refugees, it is understandable why Muslim refugees seek to make a new home in Southern California.

Another pull factor for Muslim refugees to Orange County is the community that has been built there. For instance, "Little Arabia" in Anaheim is a "center for Orange County's Arab-American community."[20] What started as a small, working-class community in the 1950s grew significantly in the 1990s after many immigrants from Arab countries such as Egypt, Syria, Lebanon and Palestine arrived.[21] According to the Little Arabia website, "local Arab American business leaders began buying distressed homes and selling them to Arab immigrants."[22] Little Arabia is now home to more than fifteen eateries and cafes, seven service businesses, and six religious institutions. This community can make refugees and immigrants feel more at home when in Orange County, and can be a major pull factor to the area.

In addition to these appealing factors, however, many other complicated policies affect where refugees ultimately settle. Owaiz Dadabhoy, a representative from UPLIFT charity, explained that "the federal government negotiates with on-the-ground voluntary agencies that contract with the State Department."[23] He added that

from there, "local non-profits help determine which cities are good for relocation, with a special emphasis on housing availability and affordability."

Adjustment to Orange County

When relocated, refugees have to adjust to life in Southern California. According to Dadabhoy, everyone adjusts differently, based on their personal circumstances, background, age, and other characteristics. There are some outside factors that go into this, as well. For example, "those who speak English already have an advantage." Additionally, when it comes to employment, Dadabhoy adds that older people have a hard time finding work. "Almost all the time they need organizations to assist them in the short term till they get set with a job." UPLIFT found that the hardest aspect of resettlement in Orange County for refugees was finding jobs. In fact, "most are very employable but some have language challenges or disabilities due to the wars or other situations." Furthermore, the high cost of rent in Orange County makes it difficult for refugees to afford housing. According to the US Census department, Orange County's median household income in 2017 was $81,851; this high-income level raises the cost of living, which means affordable housing in Orange County is rare.[24] Thus, refugees often have to continue to rely on the government for a short period of time.[25] Despite these hardships, Muslim refugees work hard to integrate and contribute to their new communities.

Despite these challenges, the UPLIFT representative stated that most Muslim refugees are generally happy and work hard to contribute to their community.[26] Dadabhoy also pointed out that "[organizations] like ours keep them going till they become self-sufficient. Their children become successful, which is great, given the hardship their parents went through."[27] It seems that Orange County will continue to settle refugees fleeing their home countries, while the refugees will continue to give all they have to make a better life for themselves and their children.

Looking Ahead

Because of the many factors pushing refugees out of their home country and pulling possible refugees to Orange County, Southern California sees many resettled Muslim refugees. The appeal of Orange County can be attributed to the way they are welcomed, the existence of various nonprofits offering support and the established communities already there. Many Muslim refugees continue to settle in Orange County, and despite their challenges, they ultimately seek to be integrated into a community and make a new home for themselves and their families.

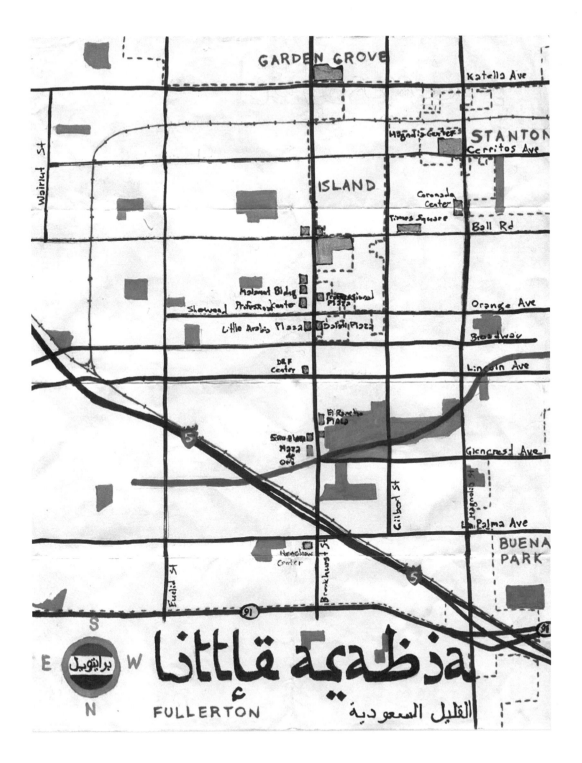

The 7-panel Fairfax Community Mural depicting the 1841-1985 history timepiece of the Jewish community in Los Angeles. (Eliana Park)

the historical impact of fluctuating immigration policies

by Kelsie Thompson, Devin Sutorius, and Jack Ryan Wineke

"My grandparents came to Ellis Island because they came from a war-torn country in Lebanon."
-Joyce Anderson

Immigration has always played a significant role in the history and shaping of the United States as a nation. People have entered the United States for a variety of reasons, many of which have transcended time and are commonly shared among all immigrants, yet each have faced their own set of challenges. Perhaps one of the greatest challenges is navigating the ebbs and flows of far-reaching policies and the deeply rooted ethnic sentiments that surround them. Over time, immigration policy in the United States has fluctuated between openness and restrictiveness. Issues such as depression and loss of jobs, fear of foreign radicals and fear of the impact of cultural differences have been key factors in times of restricted immigration. In recent years, Middle Eastern immigrants have been among the most impacted by these fluctuations.

The year 1850 is commonly acknowledged as the time when people began raising concerns about who was entering the United States, as it was the first time when the national census identified foreign-born citizens separately from the rest of the population, primarily due to concerns over Irish Catholics.[1] The first major attempt by the American government to actually regulate immigration came, however, when a wave of nearly 23 million immigrants from eastern and southern European countries made its way to the United States

between 1880 and 1920. The first act of Congress that restricted immigration from specific places was the 1882 Chinese Exclusion Act. According to historian Roger Daniels,

"the Chinese Exclusion Act was the hinge on which immigration policy turned. Within a few years America's once free and unrestricted immigration policy had been modified in a number of ways. Immigrants had to pay a small fee to enter, contract labor was forbidden, and the barred category was widened to include persons with certain physical and mental disabilities, those with criminal records, and polygamists. (The latter target comprised Mormons, not Muslims.)"[2]

The first piece of legislation to impact the Middle Eastern region was the 1917 Immigration Act, which created the Asiatic barred zone, prohibiting immigration from "British India, Southeast Asia, and the Middle East...though the law exempts students and certain professionals (e.g. teachers, government officers, lawyers, physicians, and chemists), and their wives and children."[3]

After World War I, another piece of legislation had a major impact on immigration to the United States. In 1921, the Emergency Quota Act introduced a new system for restricting immigration by putting limits on the number of people from "each nationality allowed to immigrate to the United States each year to 3 percent of the number of foreign-born persons of that nationality present in the United States as of the 1910 census."[4] This meant that nationalities with larger census numbers, such as European nations, had a greater chance of seeing more immigration than nationalities with smaller census numbers, such as groups from the Middle East. Shortly after, the 1924 National Origins Quota Act adjusted the quotas calculations to "2 percent of each nationality's proportion of the foreign-born US population in 1890."[5] These acts have been criticized for showing favoritism to northern and western European countries and further diminishing the growth in immigration from other parts of the world and have been interpreted as reflections of people's cautions against radical ideas entering the United States in the wake of the First World War.

One of the most significant pieces of United States immigration legislation was the Hart-Celler Immigration and Nationality Act of 1965. This act abolished the quota system implemented in the 1920s, though there was still a cap on the overall number of immigrants who could enter the United States (countries in the Western Hemisphere exempt). This window of more open immigration saw the first major wave of Middle Eastern immigrants flow into the United States. Many were recruited to work in factories, and others were reunited with family. Despite the growing sentiments of ethnic tolerance that it inspired, the Immigration Act of 1965 also marked the beginning of complications for immigrants from the Middle East. Global issues, particularly conflicts in the Middle East, sparked an "ethnopolitical awakening" among citizens of Middle Eastern descent who struggled to navigate their own perceptions of their identity in the midst of rising anti-Arab concerns.[6] These complications and anti-Arab feelings

have had tremendous implications for those who have pursued a better life in the United States.

Joyce Anderson was raised in a Lebanese community in Brooklyn, New York. During an interview with Joyce and her son Andre Anderson, she explained, "The customs at Ellis Island changed the last name of my grandparents to make them sound more American...our last name was truly Hashim-Raya."[7] Joyce explained that her family has always wanted to live an ordinary American life. However, that dramatically changed after September 11, 2001. After Arab Muslim men hijacked four planes and flew into the World Trade Center Towers, life in America forever changed.[8] In the response to the terrorist attacks, United States congress created the Transportation Security Administration (TSA) when they passed an act on November 19th, 2001. Since then, TSA has grown increasingly complicated and troublesome for many, not only for Middle East refugees, but for Arab-Americans as well.

Since September 11, 2001, Arab Americans, people of Middle Eastern descent and Muslims have been aware that they are being targeted for additional scrutiny at airports.[9] Middle Eastern refugees or people traveling from the Middle East are often required to endure extra questioning about their ethnicity, race and religion. Andre Anderson and other people of Middle Eastern descent have encountered this at airports and have expressed the anxiety that it adds to their travels. Joyce explained her son's experiences with TSA as follows: "In our family, we were never raised Muslim, we are Catholics...When Andre goes to the airport,

Even facial hair is a factor when it comes to racial profiling. (Brenna Khaw)

he tells me about the constant looks being received based on being a Middle Eastern man."[10] On one occasion, he had to receive additional security checks because he wore a hoodie and had a beard, which was an understandably difficult experience for him. Now every time he goes to the airport, he always makes sure to shave right before he leaves.[11] Even four generations since their family came to America, there remains a struggle to fit in and demonstrate that they mean no harm. In 2006, Vera Institute of Justice published a 2-year study in which Arab Americans reported an increasing sense of victimization, suspicion of government and law enforcement, and concerns about protecting their civil liberties.[12] Since 9/11, there have been serious questions about whether it is ethical to check someone based on race and ethnicity.

The Patriot Act, which was passed six weeks after the 9/11 attacks, altered the public view of Arab Americans and Middle Eastern immigrants. The legislation granted additional wiretapping and surveillance authority to federal law enforcement and gave the Attorney General the ability to deport aliens who are suspected to terrorism. The 9/11 attacks prompted the government to delve deeper into citizens' background and personal information. Americans thought this was justified for the government to do since the attacks made many of them feel vulnerable. Conversely, critics of TSA have argued that they are "emotionally profiling." TSA agents may choose to investigate someone because they are reacting based on their emotions rather than dealing with evidence in front of them. The only requirements to apply to be a TSA agent include a high school education and a security background check. Because it is a high stress job, critics like Andre Anderson want to introduce more training for TSA security guards. The attacks that occured on September 11th, 2001, have led to new immigration laws and security nearly two decades later.

The last two decades have seen some of the highest Middle Eastern immigration numbers in US history. According to a study done by the Migration Policy Institute based on data obtained from the US Census Bureau, over 69% of the current immigrant population originates from the Middle East.[13] With such a high number of Middle Eastern immigrants and refugees has come a myriad of restrictions and policies. Not only have there been differing immigration reforms and policies across presidential administrations, but the nation itself has also become increasingly divided on the subject.

One of the major issues addressed by President Barack Obama's administration was the rights of undocumented immigrants. For years, the American people and foreign immigrants alike had criticized the treatment of undocumented persons.[14] Subpar facilities and medical care were and are common for those in the US without proper documentation in preparation for deportation. In addition, many called for a change pertaining to the separation of illegal immigrant families, especially removing children from mothers.

While immigration laws were relatively strict during the Obama administration, few efforts were made to improve the treatment of illegal immigrants. In June of 2012, laws were passed prohibiting the deportation of undocumented immigrants who had been brought to the U.S. as children. This resulted in many separated families because the parents were often deported and had to leave behind their children. In total, almost 750,000 children were kept in the U.S. by the DACA (Deferred Action for Childhood Arrivals) initiative.[15]

President Obama's deportation statistics are also record-setting. Over the course of his two terms, over 2.7 million people were removed from the US, more than any other president in history.[16] His administration expanded family detention in the summer of 2014 in the hopes of averting additional migrants.[17] However, the facilities in which immigrant and refugee families were incarcerated during the Obama's presidency could hardly be considered humane. Abuse was rampant in these detention centers among detainees, as was mistreatment by guards.[18] Children were not allowed to own toys, games, or writing utensils, and neither were parents offered any privacy. Although rather strict, Obama's immigration policies paved the way for the next administration.

President Donald Trump entered office with promises of immigration reform, having heard the cries of immigrant families and the American people. His main concern, at least initially, was the Mexico-United States border. California, which shares a border with Mexico, is home to the country's largest concentration of undocumented immigrants. His solution to this was a massive concrete wall spanning across the United States' entire southern border. However, when crisis arose in Syria and the Middle East became increasingly disarrayed in 2017, President Trump proposed a ban on Middle Eastern immigration entirely, motivated by national security.[19]

In January of 2017, Trump signed an executive order barring immigration from several Middle Eastern and North African countries, as well as rejecting visas from Iraq, Libya, Iran, Yemen and Sudan.[20] However, many of the people trying to enter the United States at the time were at risk, and so are considered refugees rather than immigrants. In response to the rapidly growing number of Syrian refugees and Middle Eastern immigrants, President Trump advocated the establishment of U.S. operated safe zones in Syria.[21] His idea involved installing a 20-mile guarded base in which refugees could wait out the conflict.[22] Unfortunately, this proved to be a costly endeavor due to the need for overseas military protection. As a result, the proposal for Syrian safe zones has not been acted upon to date.

A local Angeleno orders at the deli counter at Canter's on a Saturday afternoon, choosing from options such as pickled vegetables and cold cuts. (Eliana Park)

community in crisis: Syrian refugees

by Natalie Chavez and Matthew DiNaso

"they have no idea what it is like, to lose home at the risk of never finding home again, have your entire life split between two lands, and become the bridge between two countries"
- Rupi Kaur

One March morning in 2013, Faez Al Sharaa took his normal—yet increasingly risky—walk to work in Daraa, Syria. As the Syrian Civil War between President Bashar al-Assad's regime and civilian rebel groups grew, a routine walk like this became a dangerous one. As he went to make his living, Faez was approached and detained by Syrian soldiers searching for a man seen with a handgun. He was lined up in the street at gunpoint next to three others. "We felt death upon us, and we accepted it. I can't describe it in words," Faez explains. In a seemingly miraculous turn of events, Faez and the three others were saved as an elderly woman pleaded for their lives in the middle of the road. They were her son, her nephew and her neighbor. Faez was a stranger whose life was held in the hands of another stranger. Being a stranger has since become a theme in his life. A day later Faez and his wife joined a group of unknown smugglers to get to the border of a new country in search of safety. The journey to the car which drove them through the war zone included a 90-minute walk, during which a missile nearly struck them. Once in neighboring Jordan, the couple entered into a refugee camp of 80,000 displaced strangers. For two years they waited, applying for asylum in Europe twice before being told they would be sent to the United States—a distant and seemingly less welcoming land. After several interviews, meetings and periods of waiting nervously, Faez, his wife and their newborn daughter finally boarded a plane to cross the Atlantic.[1]

The Sharaa family escaped violence and political instability to come to the United States. Upon arrival, new challenges such as a foreign language, debt and political opposition to refugee programs awaited them. Today, Faez has been able to overcome these as well. He works the overnight shift stocking shelves at his local Walmart and has steadily improved his English. He and his wife have welcomed a new daughter to their family and have found a community with other refugees at a nearby mosque.[1] There are thousands of stories like these as the number of displaced Syrians rises. The United States has welcomed Syrians fleeing the civil war but remains one of the most exclusive nations when it comes to admittance of refugees. Those who do gain asylum in the U.S. are relatively few and lucky.

Syrian refugees are a people bleeding out of a devastated nation by the millions. More than half the population is struggling to escape disaster.[2] Syrians face seemingly impossible—and in many cases—life- threatening obstacles on their journey to survival. These political, economic, cultural and religious hurdles that plague Syrians might baffle an outsider. Why would a person want to jump through so many hoops? However, one must understand the perspective of a Syrian parent who puts their child on a dilapidated boat on a perilous voyage westward with no guarantee of finding a home and not a penny to their name. A person is only this desperate when the land they called home has been utterly devastated with no foreseeable chance of recovery. When communities are so radically shattered by crises, they must adapt or become outcasts in the new environment they settle in.

 Although the exact origins of the current Syrian turmoil and displaced persons crisis remains up for debate, most agree that the recent wave of violence dates back to March 2011, when political protest sparked the nation's bloodiest civil war to date. Protesters in the southern city of Deraa took to the streets to protest the arrest and torture of children who had painted anti-government graffiti in public spaces. The protests did not call for the overthrow of President Bashar al Assad but rather reflected a range of grievances. Security forces responded brutally, killing some civilian protesters. As a result, the protests spread to other cities. By June 2011 over 500 people had been killed and thousands of Syrian residents had fled into Turkey, marking the beginning of large-scale refugee movements.[3]

The Syrian Civil War has claimed the lives of an estimated 500,000 people, up to 10% of whom have been children.[4] Since other nations have become involved, the conflict has only grown more dangerous for those living in the war zone. As of 2016, 6.2 million people have been displaced within the country and 5.6 million have left. Over half of these people have fled to Turkey. Lebanon, Jordan and Iraq have also become central hubs for Syrians seeking safety.[5] To leave the country is nearly as dangerous as the war itself. However, it is the only

Fairfax, infamously known to encapsulate the in vogue culture of Los Angeles, frequents families and loved ones of Canter's Delicatessen. A 1931 landmark of Los Angeles still serves baked goods, mile-high pastrami reubens and a homey ambiance. The smiles of those who serve customers are of the third and fourth-generations of the Canter family.
(Elianna Park)

option millions of people have. Whether by land or by sea, the process requires money, patience, and perhaps the riskiest investment, trust. Many refugees put their lives into the hands of strangers hoping that they will deliver them to safety.

Camps run by the United Nations High Commissioner for Refugees (UNHCR) offer the greatest chance at resettlement for refugees. However, the process is long and nothing is guaranteed. The UNHCR will determine which refugees should be resettled and begin the process for screening in the United States. The U.S. screening is rigorous and lengthy with cross checks by up to nine government departments. Syrians specifically may be flagged for extra screening due to fears of extremists from the war exploiting the system. This process is expected to take 18-24 months, but in reality may take years.

Syria was not always a war-torn country scattered with sobbing mothers and malnourished children. And contrary to popular belief, the first wave of Syrian immigration to the United States traces back as far as the late 19th century. Those early Syrian immigrants were primarily Christians, pressured by changing demographics within their homeland, stories of economic prosperity in the West and persecution by the Ottoman Turks. Syrians in this era were originally thought to be short-term migrants who would send money back home. However, job opportunities led them to establish roots in the United States. This settlement did not come without its hardships—finding community in a new nation, struggling for economic success, xenophobia and cultural boundaries were difficult for any first-generation immigrant to overcome.[6] Like many other foreign people groups, early Syrians immigrants struggling to assimilate to American culture often ended up living in ethnic enclaves across the country to support one another with employment and learning English. They married within their communities in order to keep their traditions alive and community growing. New York became one of these cultural hubs for the growing, business owning, Syrian middle class during this time.

As nativist policies took root in the U.S. and across Western Europe in the early 1910s, Syrian immigrants fought to earn citizenship but had to do so through rapid assimilation to American culture.

care deeply about their perceived racial status, possible conversion to Christianity, and how it would affect staying in America.[7] After passage of the Johnson-Reed Immigration Act in 1924, which placed quotas on immigrants based on how many people of that nation were living in the nation at the time, Syrian immigration became nearly non-existent.

Until the end of World War I, the region known as Greater Syria, or simply Syria, belonged to the Ottoman Empire and included Lebanon. After the Turkish defeat, France assumed political control of the region [...] countries finally attained their independence: Syria in 1946 (capital Damascus)[8]

Once the Syrian people regained their independence, there was more freedom for people to migrate as they chose and this is when Syrians from a Muslim background began immigrating to America. These numbers grew exponentially after the Hart Cellar Act of 1965,

known commonly as the Immigration and Naturalization Act, which lifted most of the quotas of the 1924 Act. It was a good time for Syrians and other Middle Eastern people groups to move; many of their homelands had newfound independence after lifting off the shackles of colonialism, but these young nation-states were susceptible to government corruption.

Chaos first struck in 1982 in the Hama Massacre where an estimated 5,000 to 2,500 Muslims perished, protesting what they felt an oppressive regime, but those who supported the government saw it as a necessary tragedy to protect the nation's way of life.[9] Whatever the perspective, this national disaster became a catalyst for the rise of the Syrian Muslim Brotherhood, which remains a key player in the current Syrian chaos.

Today, of the 5.6 million Syrians who have left their homes in search of asylum, the United States is now home to an estimated 33,000.[10] Legislation passed during the Obama and Trump administrations has limited the acceptance of refugees from Syria; however the Trump administration has been much more restrictive. California has become the leader of Syrian resettlement in the United States. In 2016, the state took in 1,745 Syrian refugees, nearly more than the entire nation had taken in the last five years combined. That number was reduced to merely 4 in 2018 due to restrictions placed on refugee resettlement.[11] In total, California is home to an estimated 26,000 Syrian refugees. Los Angeles is the central hub for Syrian resettlement in the U.S. with nearly 13,000 refugees placed. Refugees in the area have found solace and community, often through shared mosques or cultural enclaves like Anaheim's Little Arabia. Several Syrian restaurants and hookah bars have sprung up and offered a familiar scene for refugees to gather and mingle.[12] Against all odds, those who have come to Los Angeles have built a home away from home.

Although crisis may greatly alter what community looks like, the displaced Syrian community as a whole is thriving in the harshest of climates by leaning into their personal faith and the legacy of perseverance their heritage carries. Although no migrant experience is a monolithic one, there is yearning for finding home again or creating that sense of security in a world that seems everything but safe. Out of this tragedy, the nations of the world can use this contemporary crisis in Syria to reflect on how as a global community we respond to disaster that doesn't directly affect us or offer reward for aide. And for the damage done to this nation whose name means northern land, there is hope like the northernmost stars, the resilience of the Syrian community at large shines beyond the depravity suffered and there will be restoration for all those who wander to find their way home.[13]

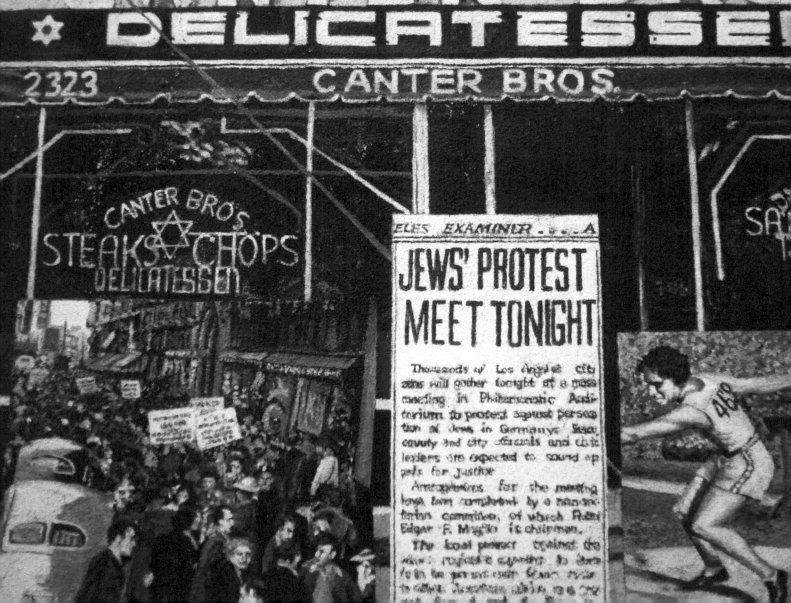

One of seven panels of the Art Mortimer's Fairfax Community Mural shows what would be the front of Canter's Deli. (Fiona Park)

CANTER BRO

DELICATESSE

2323 CANTER BROS.

CANTER BROS
STEAKS CHOPS
DELICATESSEN

ELES EXAMINER

JEWS' PROTEST MEET TONIGHT

chapter fifteen

history of middle eastern jewish refugees in los angeles

by Matthew Lancaster and Philip Knapp

"I swore never to be silent whenever and wherever human beings endure suffering and humiliation. We must take sides. Neutrality helps the oppressor, never the victim. Silence encourages the tormentor, never the tormented"

-Elie Wiesel

Los Angeles is known to many as the city of dreams, but for the Persian Jewish community it is a fresh start. The city provided financial opportunities and security for those who fled from Iran. This fresh start wasn't without hardship and discrimination, however. Why did they leave their country?

September 8, 1978—a day that would change the course of history for Iran. It would also be the day the door opened for hostility toward Persian Jews. It was Friday. The weekend was beginning for many around the world, but those in Iran were about to experience a moment that would change their lives. The streets were filled with the spirit of revolution as both young and old marched to Tehran's Jaleh Square. Protests had been heating up and those wanting freedom were now defying the declaration of martial law. Jaleh Square was filling up as thousands continued to enter the square. The air was littered with sounds of chanting and voices of those seeking freedom from the royal dictatorship of Mohammad Reza Shah. Tensions had been rising in recent years as many different groups—nationalist, communist, Islamist and everyday citizens—were tired of the policies of the Shah. Outside countries, however, saw him as a great leader who was fostering much needed changes in Iran.

Despite being viewed as a strong leader by the West, the Shah's people were turning on him. Increasing tensions about how the country should be run were resulting in protests and calls for the Shah to be removed. According to a sociologist, "Opposition figures continued to be arrested, including twenty-five religious scholars in mid-1977, the most prominent being Ayatollah Mahmoud Taleghani, a senior religious leader and longtime liberal opponent of the regime."[1] This all came to a head on the night of September 8, 1978. As the crowds continued to protest, the military that was in Jaleh Square was preparing to silence the protesters. Unbeknownst to them, many were about to be gunned down without cause.

The sound of gunfire erupted into the night air as people began to topple over. Without notice, the military had opened fire on the protesters. Thousands ran to safety as hundreds were gunned down in cold blood. This was the turning point in the revolution known as Black Friday. Farangis Hasidim, the head nurse of Sapir Hospital in Tehran, would inform the hospital that they were bringing in the injured. Sapir Hospital was a long-standing Jewish hospital in Tehran. They were known for catering to the Jewish community, but that night everyone was welcomed. According to some reports, they helped up to 90% of the injured.[2] The Persian Jewish community, including leftist activist Edna Sabet, was not only participating in the revolution but also saving the lives of those protesting. In 1979, this peaceful coexistence would change when Ayatollah Khomeini, the founder of the Islamic Republic of Iran, took control of the government. This would set the stage for the exodus of many Persian Jews who had lived in Iran for centuries.

Persian Jews have a long history in Iran which dates back centuries. Some scholars have estimated that they settled in the region around 540-700 B.C.E. The Persian Jews built up a long-standing culture of artisans, artists and entrepreneurs. They built strong, close-knit communities and sometimes participated with other cultures. When the Shah took control of the country in 1941, they found themselves experiencing newfound religious freedom. Along with this came economic prosperity. Historian David Menashri points out that prosperity "reached its peak in the era of the 'White Revolution' (beginning in 1963), the 'Golden Age' of Iranian Jewry, when Jews enjoyed almost total cultural and religious autonomy, experienced economic progress, and had no less political freedom than their Muslim compatriots".[3] Things began to change in the mid-70s as the citizens were tired of the way the government was being run. Following the revolution, Ayatollah Khomeini took over and began his totalitarian regime. This struck fear in the hearts of the Jewish community which saw an increase in anti-Semitism, religious persecution and murder occurring under the new regime. One event that would set the stage for the exodus to occur in Iran was the death of a prominent Jewish community member.

One famous figure of Jewish culture to face persecution at the hands of the new government was Habib Elghanayan. He grew up poor in Iran and became a self-made millionaire. Dr. Houman Sarshar explains, "With his brothers, they eventually built one of the largest and most successful diversified industrial and manufacturing conglomerates in modern Iran."[4] He brought plastics to Iran and in doing so became a wealthy businessman. "He was known in Iran for his philanthropy and involvement in the Jewish community. Habib was a member of the Chamber of Commerce in Iran and the

president of Tehran's Jewish Society for many years."[5] Elghanayan was also someone who would help those in need, including those who were not Jewish. His grandson pointed out how "he had worked to form partnerships with Muslim and Armenian businessmen, how he had rehabilitated hospitals—including one in which injured revolutionaries were treated—and had funded charities to help poor schoolchildren and the elderly."[6] Yet the Ayatollah arrested Elghanayan on trumped-up charges to make an example of him.

He was accused of being a spy for Israel and supposedly giving Israel large sums of money. None of the charges could be proven and were outright denied by Elghanayan himself. After months of imprisonment, he was brought before the Islamic Revolutionary court on May 9, 1979. Habib Elghanayan was executed by a firing squad. He was one of the first citizens to be murdered by the court. This event, according to some, may have been a message to the Jewish people. The government was striking fear into them. The days of freedom were beginning to come to an end as the new regime took over. Elghanayan wasn't the only Jewish individual to be killed by the regime.

Edna Sabet, a young revolutionary who was part of the controversial leftist organization Mujahidin-i Khal or People's Mujahedin of Iran, was another casualty of revolution. The group was made up of predominantly Muslims—except for Sabet—who was Jewish. She had become a political activist in college and wanted to see change come to Iran. Mujahidin-I Khal employed a mix of Islamist and Marxist thought. The revolutionaries were not opposed to violence either. They were not allowed to participate in a 1979 election, and this angered the movement. The government eventually arrested several members, including Sabet. She was tortured and executed by the government, which was becoming increasingly hostile to those who spoke against the Ayatollah. The climate in Iran was changing for Jewish people who once stood for revolution. Fear was becoming commonplace, and the Persian Jewish community began its exodus from Iran. Two prominent areas of resettlement were in New York and Los Angeles.

The refugees that migrated from the Middle East to Los Angeles, including the Persian Jews, have contributed substantially to the community. These Sephardic Jews, who migrated from Israel and areas around it, contributed to the community through the building of synagogues and community service. These Sephardic synagogues are in Westwood and Brentwood. They faced challenges such as difficult living conditions when they first came in the 70s and 80s. The living conditions were better than what they experienced in the Middle East, but they were not up to the standards of the average Los Angeles resident. These Jews had the struggle of being seen as equal citizens but not as equal Jews.[7] They were thought of as lower class by the Ashkenazi Jews (European). The Ashkenazi were already an established group, and the arrival of this less fortunate Jewish group led them to believe they were superior. These Ashkenazi Jews put many of the Sephardic Jews down because they didn't have the same financial income and they didn't look anything like the Ashkenazi. One reason why many Sephardic communities were tightly wound was so that they could hold onto their culture and heritage.

Other Middle Eastern Jews came from further east than Israel. These Jews came from Iran and are Iranian, but they called themselves Persian because of the backlash that came with the word "Iran" during the Iranian

Sitting on the street corner of Westwood Boulevard is the Westwood Jewish Center, where Rabbi Kashani has served the community and those in need for over 20 years. The surrounding area is what makes up a neighborhood: a grocery store across the street and other locally owned businesses. (Eliana Park)

Revolution of the 1980s. These altercations showed that Americans didn't like these Iranians, which is why many stayed to themselves. Over time, attitudes towards them began to change and became more positive. They soon experienced discrimination after 9/11, however, along with Muslims from Iran, because of the fear that people coming from the Middle East could harm them in some certain way. The younger generation of these Jews looked American, but they continued to identify as Iranian/Persian.

Integrating into American society often leads to struggles. Many of the 2nd generation Sephardic and Persian Jews lost the culture and faith of their parents and grandparents, but they will never stray away that their Iranian heritage and culture. These Persians were more traditionally family centered than faith centered.[8] One way to find a sense of belonging was through athletics. Athletics and schoolwork made these Jews feel more comfortable being around people like them and as well as competing against other Jewish schools. All Jewish schools consisted went through high school and competed against other schools academically and athletically.

Jewish refugees from Iran had to have money, or they could not travel to the United States. A sizable portion of Persian Jews found refuge in Beverly Hills—where they comprise one-fourth of the population.[9] They also spread into Westwood, Santa Monica and down Rodeo Drive. Purchasing area on Rodeo Drive was expensive, so the wealthier Persian Jews soon set up shop for almost $200 per square foot, buying either real estate or restaurants. Some could afford for their houses to look like the ones in Iran, and Rodeo Drive is evidence of this. Others found themselves on Westwood Boulevard running ice cream shops and restaurants. By 1990, 20% of the Beverly Hills Unified School District had come from Iran.[10] These Persians Jews worked in the financial sector and international trade. The idea of leaving the oppressive regimes of the Middle East to seek freedom and prosperity in Los Angeles was attractive to them. As more immigrated to Los Angeles, they began to influence local government. Both rich and poor were able to gather enough resources to survive in a new country, and there was one thing

they all had in common. "As a whole, Iranian Jews kept to themselves, preferring the familiarity of their own social networks and Persian cultural traditions".[11]

Integrating into American culture was hard at first for many Persian families, but soon many thrived in the areas around Los Angeles.[12] They established synagogues throughout the region, including the Sani Temple, a conservative Jewish establishment, and Temple Beth-El in Hollywood. Chloe Pourmorady is a musician who has created beautiful worship songs in both English and in Persian. Even though she never has been to Iran, the culture and the heritage still live with her. Her music gives her the sense of belonging to not only her culture and tradition, but also her faith. The percentage of Persian Jews has risen since the early 1980s because later immigrants from Iran have found a welcoming community. When Jimmy Delshad was elected mayor of Beverly Hills in 2007, he became the first Persian Jewish mayor in Los Angeles County. This was a big step forward politically for Persians Jews. In an excerpt, Delshad explained that there were only 10-12 Iranian Jewish families in the area he grew up but the population exploded in the late 20th Century and into the new millennia.[13] These Persian Jews may have come from a place of persecution, but they have made a name and a lasting impact for their Jewish heritage in Los Angeles.

Middle Eastern Jews have long been refugees, from the Babylonians taking over the kingdom of Judah to the Muslim state taking over Iran. Just like early Americans, they looked for a better life and freedom from a government that thwarted their religion. Persian Jews from all backgrounds migrated to Los Angeles in hope of a better life. The climate in Los Angeles resembled Iran and the coast of Israel. Settling in Hollywood, Beverly Hills, Westwood and Brentwood brought them to an area that already contained a community of Jewish culture. Many Jewish schools and colleges sprang up around the larger Los Angeles area due to the influx of Jewish immigrants and refugees coming into the area. Now there are plenty of areas where Jews can feel secure. For example, Little Persia, located on Westwood Boulevard, is one of these places. Even though they are refugees from other lands, they still carry their culture with them, and the later generations blend their former traditions with their new Americanized culture.

Many Persian and Jewish families have found a home in the Los Angeles area. (Eliana Park)

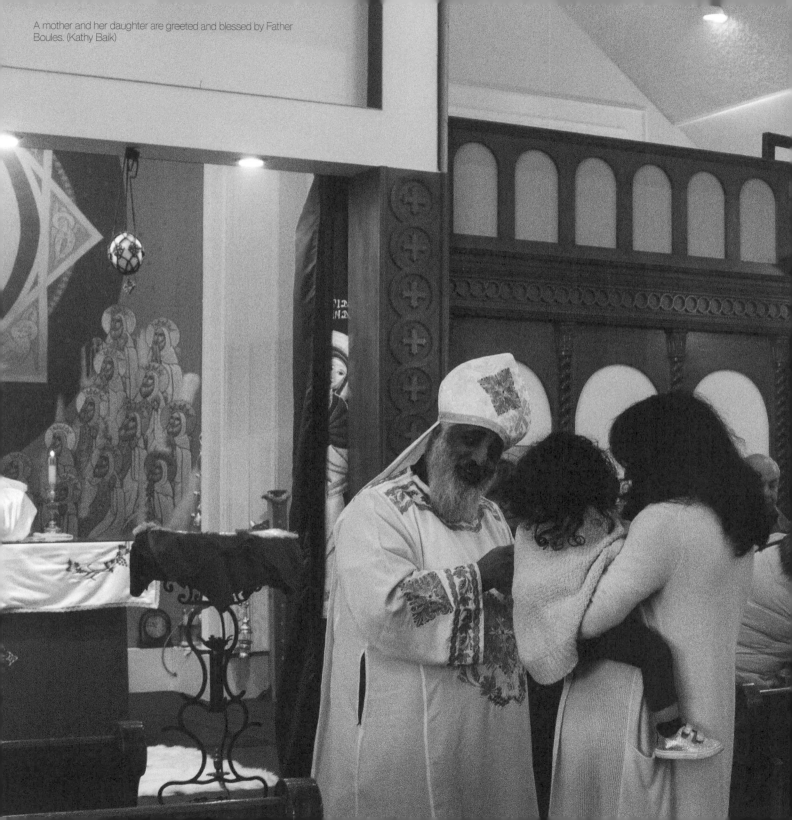

A mother and her daughter are greeted and blessed by Father Boules. (Kathy Baik)

the coptic exodus

by Zach Nash and Jessica Penner

"Martyrdom does not end something, it only a beginning."
-Indira Gandhi

On February 15, 2015, a grotesque video was posted across the internet showing men displaying true evil—and men displaying true courage in the face of that evil. The video was claimed by the Islamic State and shows twenty-one men from the Coptic Christian Church, the largest Christian denomination in the Middle East, martyred for their faith at the hands of militants from the Islamic State. The Coptic Christians, wearing bright orange jumpsuits and black bags over their heads, were dragged out by the Islamic State militants, dressed in all black, onto a beach in Libya and had machetes held to each of their throats. One of the militants spoke in English with Arabic subtitles, giving a message entitled, "A Message Signed with Blood to the Nation of the Cross" that declared their reasons for their abhorrent vengeance. Then each one of the Coptic Christians were given a chance to deny their faith but not one of them gave in, many even breaking out into songs of worship, refusing to bow down to the forces of evil. Then in a syncopated savagery, the militants simultaneously beheaded all twenty-one of the Coptic Christians.[1] It is oppression like this that has led thousands of Coptic Christians to leave their homes and seek refuge in Southern California.

The Era of Nasser

The Coptic Christians' representation in the Egyptian government had been steadily declining during the first half of the 20th century, but after Gamal Abdel Nasser took power after the Egyptian Coup d'etat of 1952 their representation completely disappeared. Nasser's nationalization policies and confiscation of large landholdings proved to be detrimental to the Coptics' economic state. Although Nasser himself was very secular, his education

minister, Kamal El Din Hussein, highly Islamized the Egyptian educational system. This was very concerning to the Coptic Christians. The Copts did benefit from Nasser's crackdown on the Muslim Brotherhood, but this proved to be only a temporary solution. The damaging results of Nasser's regime to the Coptic community caused many Coptic Christians to leave their homes in Egypt and seek refuge in other nations.[2]

The First Wave

During the 1950s, the largest diaspora of Coptic Christians from Egypt in history began. During Nasser's regime, many Coptic Christians began moving to North America, Europe, Australia and all across the world in search of greater economic opportunities and more religious freedoms. Several Coptic Christians began coming to the United States during the mid 1950s, but the United States' strict immigration policies made it very difficult for immigrants to become citizens. However, the Immigration and Naturalization Act of 1965, also known as the Hart-Celler Act, replaced the previous quota system and sought to attract the immigration of skilled workers. This major immigration policy change allowed for many more Coptic Christians to come to the United States in search of better lives. The first official Coptic church in the United States was founded in Jersey City in 1965 under the authorization of Pope Cyril VI of Alexandria. Coptic churches in Montreal and Los Angeles were established shortly after and Coptic churches began spreading across the United States.[3]

The Second Wave and Growing Political Influence

The Immigration Act of 1990 increased the number of immigrants allowed into the United States, prioritized giving work visas to skilled workers, and also introduced the lottery system. As a result of the Immigration Act of 1990, the Middle Eastern population in the United States almost doubled in just over ten years.[4] The 1990s were a significant time for the Coptic Christians in the United States, not only for population increases but also for their increasing political influence. For example, in 1997, the Freedom from Religious Persecution Bill, which placed sanctions on countries failing to respect their religious minorities, was introduced. Many Copts strongly advocated for this bill, although many other Copts were opposed to it, and in 1998, a modified version of this bill, the International Religious Freedom Act, was passed. The Coptic Christians began to play a significant role in conservative Christian groups such as Christian Solidarity International and the Center for Religious Freedom.[5]

The Third Wave- 2011 Egyptian Revolution

The third wave of Coptic Egyptian migration started in 2011 and continues even now. In 2011, Egyptian President Hosni Mubarak faced days of intense protest and was forced to resign, leaving power in the hands of the Supreme Council of Armed Forces. A new presidential election followed, resulting in the election of a Muslim Brotherhood candidate, Mohamed Morsi.[6] According to Cairo University professor, Mai Mujeeb, the new Islamic influence shown in the presidency and the Muslim majority in parliament produced a hostile environment for Copts, especially in the professional

arena. The exclusion of qualified Copts in government and institutional positions created an economic need for change, while dramatically weakened political influence reflected a shift towards unbalanced power. On March 19, 2011, the first democratic vote since 1952 was held. The decision being made was in regard to the order of the recreation of the government—the bill would place the elections for parliament before the writing of the constitution. The Muslim Brotherhood and traditional groups supported the proposed action, while the Copts and more liberally inclined groups opposed the measure. The political weakness of non-Islamic groups was reflected in the overwhelming 77 percent of voters approving the bill.[7] Reluctant Copts left and are continuing to leave their homeland due to the political uncertainty, increased targeted violence and economic challenges.[8]

Migration Patterns

While it is difficult to have precise statistics on the number of Copts immigrating because of their lack of distinction from Muslim Egyptians, the fact that the number of Coptic immigrants to southern California has increased significantly is irrefutable.[9] Dr. Khalil estimates that the first group that arrived in 1963 consisted of about 100 people. Within just ten years, that number had increased to 3,000 and reached 25,000 people in 1985 before the second major wave of migration hit. By 2010 the Coptic population in southern California is estimated to have risen to 75,000 immigrants and as of 2018 the estimation rests at 100,000. (Figure 1) In addition to the immigrants legally accounted for, the Migration Policy Institute estimates that there are approximately 2,000 unauthorized Egyptian immigrants in Los Angeles county.[10] This surge in Coptic immigration growth

Figure 1 [11]

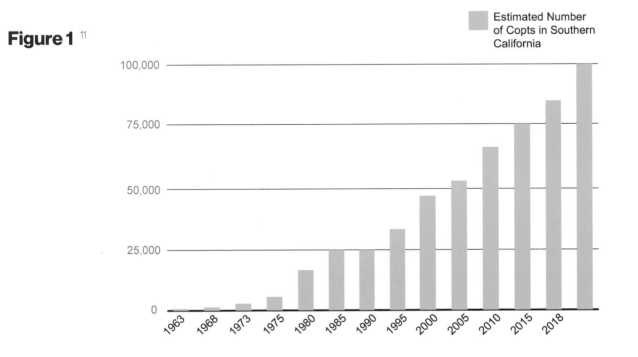

Estimated Number of Copts in Southern California

compared to that of Muslim Egyptians is supported by the paralleled growth in the number of Coptic Churches in southern California. (Figure 2)

Socioeconomic Circumstances

Before the second wave of immigration (random selection) in 1990, the majority of Coptic immigrants who came to the United States were highly educated. The majority of adult Coptic immigrants were well educated, having earned at least a bachelor's degree and almost half having achieved master's or doctoral degrees.[13] However, due to many challenges such as paperwork, language barriers and and difference between American and foreign degrees, many immigrants begin occupying simple jobs. Despite their education, they often work as gas attendants, cashiers or security guards.[14] For some, this is a temporary situation as they pursue professional licenses or attempt to increase qualifications, but for others the high living expenses make it very difficult.

Despite difficulties, the Coptic move to the United States seems to generally follow the trajectory of the 'American dream.' Studies show that upward mobility on the socioeconomic ladder is very possible and is often accompanied by better assimilation into mainstream society.

Challenges

There are many challenges Coptic Christians face in their transition to life in southern California. According to first generation immigrant Yvette Shenouda, language is one of the most difficult obstacles. The language

Figure 2 [12]

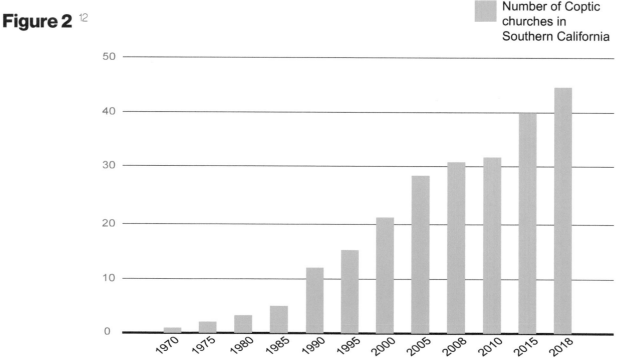

Number of Coptic churches in Southern California

barrier is two-sided. English is a very difficult language to learn. Even for those who were taught English in Egypt it is a challenge, because they learn British English, which is complicated by American accents. Conversely, many Americans struggle to understand Egyptian accents. Another hurdle for immigrants is transportation. California, unlike Egypt, has an abundance of complex traffic rules, creating a significant learning curve. During the learning period, Copts must rely on limited and expensive alternative means of transportation. The existing Coptic churches in southern California communities seem to be the best resource for new immigrants by creating programs that aid in and facilitate the process of integration.[15]

Cultural Integration

Coptic immigrants actively continue their traditional culture to varying degrees through many aspects of life: church, home, family, work, food and music. They adapt to their circumstances in the United States while preserving much of their culture. Ideally, many Copts would like to have 'family homes' in which multiple generations share the same building, but each floor is equipped with all necessary living spaces. However, the high prices of living and property in California make it unlikely that many will get to live this way.[16] Another traditional ideal that is translated to their lives in southern California is professional ambition. "The reason for this is a traditional belief that they can be successful only if they achieve the highest possible level of education."[17] According to many youths in the Coptic community, their elders have high expectations for a strong education and professional career. One of the most notable generational gap struggles is a difference in ideas of dating. Many of the young Copts in the Southern California area view dating as many other youths would, as a casual or potentially serious way to decide on a future spouse. More traditional views of finding a spouse vary but generally do not include casual dating, which can be a significant portion of social life for young people. As is the case for many of the immigrant groups in the United States, Copts find America to be a melting pot where they have the freedom to maintain their culture while adjusting to the influences of other cultures.[18]

Conclusion

The three waves of Coptic Christian immigration to Southern California have all been the result of religious persecution that has manifested in violence, economic exclusion and political uncertainty. In dramatically increasing numbers, Copts have made the greater area of Los Angeles and Orange County their home. Despite challenges such as language barriers and transportation, Copts have been able to build communities and steadily flourish. Centered around the church, many aspects of traditional Coptic culture are well maintained while also being infused with the unique blend of the many other diverse cultures that make up Southern California life.

afterword

by Michal Meulenberg, Ph.D

"So you're Christian?" I nodded in agreement. "Oh, that's so interesting! I just took a class on Christianity" said the middle-aged Muslim woman, ready to start engaging me in conversation about what she'd learned about the faith I was raised with. "No way! How cool! Where did you take the class?" I asked. "At my mosque... it ended just last week" she happily responded. I was surprised. "Interesting! Who was teaching it?" She mentioned the name of the teacher and it became clear it was a Muslim scholar who had studied Christianity and was teaching other Muslims about it.

On the one hand, this kind woman made me feel appreciated. She had taken an interest in how I understood and practiced my faith; yet I felt a bit uncomfortable. All kinds of questions went through my mind: "What was she taught about my faith? About the Bible? Would the teacher have confirmed some of the common misunderstandings or worked to address them? Also, why was a mosque holding a 7-week class about Christianity? What was the purpose? Were the participants supposed to go out and convert us or just know more about us? And, most importantly: Why not ask a knowledgeable Christian to teach about their faith? Wouldn't that be a better representation, more helpful for the audience to learn from someone who actually practices the faith?"

Then it hit me: Christians do exactly the same thing! They host classes about Islam taught by other Christians. In fact, I was doing that. When people find out I have a heart for peace-building between Muslims and Christians, they ask me to come teach them about Islam as if I'm an expert. I decided this needed to change and started interviewing Muslims on camera, taking students on visits to local mosques and Muslim organizations. I assigned documentaries made by Muslims to my students as well as having them interview Muslims for their papers— anything to ensure that these Christian undergraduates would actually meet and hear Muslim perspectives in ways they'd perhaps never have tried unless prompted.

Treat others the same way you want to be treated, Jesus said. What does that mean for our understanding of Muslims, their faith, of the conflicts happening in the Middle East, of refugees seeking shelter in North America? There is so much talking about them and very little with them. No one likes others to speak for them, so making time and effort to actually meet people and hear their stories is a way of demonstrating love in action.

That is exactly what this book is doing. Instead of letting students learn about Middle Eastern and refugee communities in Southern California from books or people who have not walked in their shoes, students participating in this project went out to meet people, interview them, and collect their stories.

Let this book challenge us all to make it a personal goal to treat refugees and others from the Middle East the way we want to be treated: to get to know them!

———————————

Born in the Middle East, but raised in Europe, MICHAL MEULENBERG came to the U.S. in 2005. She considers herself a peace educator and is passionate about mobilizing the next generation to be reconciliation workers in their own lives, locally and around the world. Meulenberg serves on the faculty at several different schools, teaching Muslim-Christian relations, Islam in North America, (Religious) Conflict & Reconciliation, Mediation, and (grassroots) peacebuilding. She co-founded Two Faiths One Friendship, a grassroots peace-building initiative focused on bringing together Muslims and Christians who were raised in evangelical backgrounds. Meulenberg holds master's degree in English and Journalism, in Divinity and in Intercultural Studies. Her Ph.D is in Muslim-Christian Relations.

endnotes

chapter eleven

[1] 'When a Muslim Child is called Terrorist," KARAMAH, last modified March 21st, 2018, accessed March 25th, 2018, http://karamah.org/press/when-a-muslim-child-is-called-terrorist.

[2] "Citizenship and Immigration Services," Homeland Security, last modified February 25th, 2019, accessed March 1st, 2019, https://www.dhs.gov/.

[3] "The IRC in Los Angeles," International Rescue Committee, last modified January 18th, 2019, accessed February 9th, 2019, https://www.rescue.org/united-states/los-angeles-ca.

[4] "Citizenship and Immigration Services," Homeland Security, last modified February 25th, 2019, accessed March 1st, 2019, https://www.dhs.gov/.

[5] "Who is a Refugee?" Refugee Council USA, last modified January 30th, 2019, accessed February 9th, 2019, http://www.rcusa.org/who-is-a-refugee.

[6] Yvette A. Shenouda, "Planting for Coptic Egyptian Immigration Integration in Southern California" (master's thesis, California State Polytechnic University, Pomona, 2018), 25, accessed February 15th, 2019, http://hdl.handle.net/10211.3/207813.

[7] Yvette A. Shenouda, "Planting for Coptic Egyptian Immigration Integration in Southern California" (master's thesis, California State Polytechnic University, Pomona, 2018), 25, accessed February 15th, 2019, http://hdl.handle.net/10211.3/207813.

[8] Aaron Mendelson, "SoCal's Muslim Community Geographically, Ethnically Diverse, 89.3 KPCC, accessed February 9, 2019, https://www.scpr.org/news/2015/12/11/56162/socal-s-muslim-community-geographically-ethnically/

[9] Kelley, Ron, Jonathan Friedlander, and Anita Colby. 1993. *Irangeles : Iranians in Los Angeles.*

[10] "Illusion of Justice: Human Rights Abuses in US Terrorism Prosecutions, Human Rights Watch, published July 21, 2014, accessed March 15, 2019 https://www.hrw.org/report/2014/07/21/illusion-justice/human-rights-abuses-us-terrorism-prosecutions

chapter twelve

[1] UNHR, "Resettlement," accessed January 20, 2019, https://www.unhcr.org/resettlement.html.

[2] UNHR, "Resettlement."

[3] Alejandra Molina, "How a Syrian family is adjusting to life as refugees in Southern California," *The Press Enterprise News*, February 26, 2017, accessed February 2, 2019, https://www.pe.com/2017/02/26/how-a-syrian-family-is-adjusting-to-life-as-refugees-in-southern-california/?clearUserState=true.

[4] Ibid.

[5] Ibid.

[6] Hisham S. Foad, "Waves of Immigration from the Middle East to the United States," December 20, 2013, accessed March 9, 2019, https://ssrn.com/abstract=2383505.

[7] Donald J. Trump, "Executive Order Protecting the Nation from Foreign Terrorist Entry into the United States," *The White House*, January 27, 2017, accessed March 9, 2019, https://www.whitehouse.gov/presidential-actions/executive-order-protecting-nation-foreign-terrorist-entry-united-states-2/.

[8] Tom K. Wong, "Orange County Immigration File: A Report of the OC Opportunity Initiative (Newport Beach: Orange County Community Foundation, 1989)," accessed March 10, 2019, https://www.oc-cf.org/wp-content/uploads/2017/12/Orange-County-Immigration-Report-_-2017.pdf.

[9] Hisham S. Foad, "Waves of Immigration from the Middle East to the United States."

[10] Mark Lynch and Laurie Brand, "Refugees and Displacement in the Middle East," Project on Middle East Political Science, Carnegie Endowment for Middle East Peace, March 29, 2017, accessed February 28, 2019, https://carnegieendowment.org/2017/03/29/refugees-and-displacement-in-middle-east-pub-68479.

[11] BBC News, "Trump's executive order: Who does travel ban affect?" *BBC News*, February 10th, 2017, accessed February 15, 2019, https://www.bbc.com/news/world-us-canada-38781302.

[12] Riotta, Chris, "Nationwide Protests Erupt After Supreme Court Upholds Trump's Travel Ban," Independent, June 26, 2918, accessed March 2, 2019, https://www.independent.co.uk/news/world/americas/us-politics/protests-demonstration-travel-ban-trump-muslim-groups-cair-supreme-court-rally-a8418051.html.

[13] David Bier, "Trump might not have gotten his 'Muslim ban,' But he sure got his 'extreme vetting.'" *The Washington Post*, December 10th, 2018, accessed March 27, 2018, https://www.washingtonpost.com/opinions/2018/12/10/trump-might-not-have-gotten-his-muslim-ban-he-sure-got-his-extreme-vetting/?noredirect=on&utm_term=.da694d884234.

[14] USCIS, "The United States Refugee Admissions Program (USRAP) Consultation & Worldwide Processing Priorities," accessed February 3, 2019, https://www.uscis.gov/humanitarian/refugees-asylum/refugees/united-states-refugee-admissions-program-usrap-consultation-worldwide-processing-priorities.

[15] "Demographics," *Arab American Institute*, accessed February 17, 2019, http://www.aaiusa.org/demographics.

[16] Phillip Reese, "Which California cities have refugees resettled in? Nearly all of them." *The Sacramento Bee*, January 30th, 2017, accessed February 1, 2019, https://www.sacbee.com/siteservices/databases/article129658204.html-.

[17] Emma Stessman, "Anaheim established as 'Welcoming City'" Voice of OC, December 20th, 2017, accessed March 10,2019, https://voiceofoc.org/2017/12/anaheim-established-as-welcoming-city/.

[18] Emma Stessman, "Anaheim established as 'Welcoming City.'"

[19] Ibid.

[20] Little Arabia District, "History" accessed February 15, 2019, https://www.littlearabiadistrict.com/history/.

[21] Ibid.

[22] Ibid.

[23] Owaiz Dadabhoy, interview by Whitney Siefken, February 8th, 2019.

[24] United States Census Bureau, "QuickFacts: Orange County California," accessed February 15, 2019, https://www.census.gov/quickfacts/fact/table/orangecountycalifornia/PST045218.

[25] Owaiz Dadabhoy, interview.

[26] Ibid.

[27] Ibid.

chapter thirteen

[1] Roger Daniels, "Immigration in the Gilded Age: Change or Continuity?" *OAH Magazine of History* 13, no. 4 (1999): 22, accessed February 9, 2019, doi:10.1093/maghis/13.4.21.

[2] Ibid.

[3] "Major US Immigration Laws, 1790-Present," Migration Policy Institute, last modified March 2013, accessed January 28, 2019, https://www.migrationpolicy.org/research/timeline-1790.

[4] Ibid.

[5] Ibid.

[6] Yossi Shain, "Arab-Americans at a Crossroads," *Journal of Palestine Studies* 25, no. 3 (1996): 47, accessed March 14, 2019, doi:10.2307/2538258.

[7] Joyce Anderson, Interview by Devin Sutorius, Dana Point, California, March 1, 2019.

[8] Evelyn Alsultany, *Arabs and Muslims in the Media: Race and Representation after 9/11*. (New York: New York University Press), 2012, accessed March 1st, 2019.

[9] Shaun Gabbidon, *The Influence of Race/Ethnicity on the Perceived Prevalence and Support for Racial Profiling at Airports*. SAGE publications, September 2009.

[10] Joyce Anderson, Interview by Devin Sutorius.

[11] Ibid.

[12] Andrea Elliott, "After 9/11, Arab-Americans Fear Police Acts, Study Finds." *The New York Times*, 12 June 2006, accessed March 1st, 2019, www.nytimes.com/2006/06/12/us/12arabs.html.

[13] José D Villalobos, "Promises and Human Rights: The Obama Administration on Immigrant Detention Policy Reform." *Race, Gender & Class* 18, no.1 (2011):151-70, accessed February 9, 2019, http://www.jstor.org/stable/23884873.

[14] Ibid.

[15] Ibid.

[16] Ibid.

[17] Fabricio E. Balcazar, "Policy Statement on the Incarceration of Undocumented Migrant Families," *American Journal of Community Psychology* 57, no. 1(2016): 255-263, accessed February 11, 2019, https://search.proquest.com/docview/2056423618?accountid=8624.

[18] Ibid.

[19] VOA News, *Trump Plans Immigration Ban, Supports Syria Safe Zones*. Washington: Federal Information & News Dispatch, Inc. (2017), accessed February 11, 2019, https://search.proquest.com/docview/1861811798?accountid=8624.

[20] Ibid.

[21] CAIR, "CAIR-LA: Southern California Interfaith and Civil Rights Community to Hold Press Conference on Trump Executive Orders." *Targeted News Service* (2017), accessed February 11, 2019, https://search.proquest.com/docview/1862086331?accountid=8624.

[22] Ibid.

chapter fourteen

[1] Alex Altman, "A Syrian Refugee Story: Inside one family's-two-year odyssey from Daraa to Dallas," *TIME Magazine*, November 20, 2015, accessed March 18, 2019, http://time.com/a-syrian-refugee-story/.

[2] Elizabeth Ferris and Kemal Kirisci, *The Consequences of Chaos: Syria's Humanitarian Crisis and the Failure to Protect* (Washington: Brookings Institution Press, 2016), 1.

[3] Ibid., 14.

[4] Megan Specia, "How Syria's Death Toll Is Lost in the Fog of War," *New York Times*, April 13, 2018, accessed March 18, 2019, https://www.nytimes.com/2018/04/13/world/middleeast/syria-death-toll.html.

[5] "Syrian refugee crisis," *From the Field, World Vision*, last modified January 11, 2019, accessed March 18, 2019, https://www.worldvision.org/refugees-news-stories/syrian-refugee-crisis-facts.

[6] Oswaldo M. S. Truzzi, "The Right Place at the Right Time: Syrians and Lebanese in Brazil and the United States, a Comparative Approach," *Journal of American Ethnic History*, vol, 16, no. 2 (Winter, 1997), 4.

[7] Sarah Gualtieri, "Gendering the Chain Migration Thesis," Comparative Studies of South Asia, Africa and the Middle East, vol. 24, no. 1 (2004), 74.

[8] Truzzi, "The Right Place at the Right Time,"34.

[9] Joshua M. Landis and Joe Pace, "The Syrian Opposition," *The Washington Quarterly*, vol. 30, no. 1 (Winter, 2006), 45.

[10] Phillip Connor, "Most displaced Syrians are in the Middle East, and about a million are in Europe," Pew Research Center, January 29, 2018, accessed March 18, 2019, http://www.pewresearch.org/fact-tank/2018/01/29/where-displaced-syrians-have-resettled/.

[11] Department of State, "Report on Refugee Arrivals, January 1, 2015-December 31, 2015," Bureau of Population, Refugees, and Migration, Office of Admissions, Refugee Processing Center, accessed March 25, 2019, http://ireports.wrapsnet.org/Interactive-Reporting/EnumType/Report?ItemPath=/rpt_WebArrivalsReports/Map%20-%20Arrivals%20by%20State%20and%20Nationality.

[12] Deepa Bharath, "In Anaheim's Little Arabia, Syrian refugees find a new place to call home," *The Orange County Register*, October 22, 2015, accessed March 18, 2019, https://www.ocregister.com/2015/10/22/in-anaheims-little-arabia-syrian-refugees-find-a-new-place-to-call-home/.

[13]. Ferris and Kemal, *The Consequences of Chaos*, 168.

chapter fifteen

[1] Charles Kurzman, *The Unthinkable Revolution in Iran* (Boston: Harvard University Press, 2004), 19.

[2] Lior Sternfeld, "Unintended Consequences," *Tablet Magazine*, January 14, 2019, accessed March 18, 2019, https://www.tabletmag.com/jewish-news-and-politics/278343/unintended-consequences.

[3] David Menashri, *In Anti-Semitism in Times of Crisis* (New York: New York University, 1991), 356.

[4] Houman Sarshar, *Esther's Children a Portrait of Iranian Jews* (Philadelphia: The Jewish Publication Society, 2002), 423.

[5] Ibid.,423.

[6] Shahrzad Elghanayan, "How Iran Killed Its Future," *Los Angeles Times*, June 27, 2012, accessed March 18, 2019, http://articles.latimes.com/2012/jun/27/opinion/la-oe-elghanayan-iran-entrepreneuers-not-nukes-2012062

[7] Stephen Stern, "Ceremonies of 'Civil Judaism' among Sephardic Jews of Los Angeles," *Western Folklore* 47, no. 2 (April 1988): 103-128.

[8] Mehdi Bozorgmehr, "From Iranian Studies to Studies of Iranians in the United States," *Iranian Studies* 31, no. 1 (Winter, 1998): 5-30.

[9] Max Vorspan, Llyod Gartner, *History of the Jews of Los Angeles.* (San Marino, CA: Huntington Library, 1970), 156.

[10] Bozorgmehr, "From Iranian Studies to Studies of Iranians in the United States," Ibid., 5-30.

[11] R. Stephen Warner, Judith G. Wittner, *Gatherings in Diaspora*, (Philadelphia: Temple University Press, 1998),

[12] Bruce Philips, "Accounting for Jewish Secularism: Is a New Cultural Identity Emerging?," *Contemporary Jewry 30,No.1* (June 2010): 63-85.

chapter sixteen

[1] David D. Kirkpatrick and Callimachi Rukmini, "Islamic State Video Shows Beheadings of Egyptian Christians in Libya," *The New York Times*, February 15, 2015, accessed February 6, 2019, https://www.nytimes.com/2015/02/16/world/middleeast/islamic-state-video-beheadings-of-21-egyptian-christians.html.

[2] Samuel Tadros, *Motherland Lost: The Egyptian and Coptic Quest for Modernity* (Stanford, CA: Hoover Press, 2013), 165-169.

[3] Otto F.A. Meinardus, *Two Thousand Years of Coptic Christianity* (Cairo: American University in Cairo Press, 1999), 129-131.

[4] Jie Zong, Jeanne Batalova Jie Zong, and Jeanne Batalova, "Middle Eastern and North African Immigrants in the United States," Migrationpolicy.org, January 10, 2018, accessed February 10, 2019, https://www.migrationpolicy.org/article/middle-eastern-and-north-african-immigrants-united-states-3.

[5] Nadia Marzouki, "The U.S. Coptic Diaspora and the Limit of Polarization," *Journal of Immigrant & Refugee Studies* 14, no. 3 (July 2016): 265–267, accessed March 5, 2019, http://eds.b.ebscohost.com.ezproxy.biola.edu/eds/pdfviewer/pdfviewer?vid=2&sid=f301eaf4-87e9-4f68-9b81-4d6cd050086b%40pdc-v-sessmgr02.

[6] Shinta Puspitasari, "Arab Spring: A Case Study of Egyptian Revolution," *Andalas Journal of International Studies* 6, no. 2 (November 2017): 162-166, accessed March 5, 2019, https://www.researchgate.net/publication/324688042_Arab_Spring_A_Case_Study_of_Egyptian_Revolution_2011.

[7] Jason Brownlee, *Violence Against Copts in Egypt* (Washington, DC: Carnegie Endowment for International Peace, 2013), https://carnegieendowment.org/files/violence_against_copts3.pdf.

[8] Yvette A. Shenouda, "Planning for Coptic Egyptian Immigrant Integration in Southern California" (master's thesis, California State Polytechnic University, Pomona, 2018), 15, accessed February 11, 2019, http://hdl.handle.net/10211.3/207813.

[9] D. Levinson, & M. Ember, *American immigrant cultures: Builders of a nation* (New York: Macmillan Reference USA, 1997).

[10] Shenouda, "Planning for Coptic Egyptian Immigrant Integration in Southern California," 17.

[11] Ibid., 20.

[12] Ibid., 26.

[13] Jennifer Brinkerhoff and Liesl Riddle, "Coptic Diaspora Survey," *GW-Ciber Center for International Business Education and Research* (February 2012): 9-11, https://copticorphans.org/wp-content/uploads/2018/03/CopticSurveyWhitePaperReport2-2012.pdf.

[14] Shenouda, "Planning for Coptic Egyptian Immigrant Integration in Southern California," 21-22.

[15] Jennifer Brinkerhoff, "Assimilation and Heritage Identity: Lessons from the Coptic Diaspora," *Journal of International Migration and Integration* 17, (January 2015): 468-482.

[16] Shenouda, "Planning for Coptic Egyptian Immigrant Integration in Southern California," 28-29.

[17] Ibid., 31.

[18] For more information on Coptic Christian integration in southern California including research, surveys, statistics, and recommendations see the extensive work of Yvette A. Shenouda, "Planning for Coptic Egyptian Immigrant Integration in Southern California" (master's thesis, California State Polytechnic University, Pomona, 2018), 1-12, accessed February 11, 2019, http://hdl.handle.net/10211.3/207813.

contributors

students

writers

Caleb Aguilera
Natalie Chavez
Rachel Diaz
Matthew DiNaso
Jana Eller
Fiona Gandy
Julie Hernandez
Grace Kadiman
Philip Knapp
Matthew Lancaster
Brian Marcus
Zachary Nash
Jessica Penner
Gabriel Plendcio
Colleen Sammons
Whitney Siefken
Pierce Singgih
Daniel Su
Devin Sutorious
Kelsie Thompson
Jack Ryan Wineke

photographers

Kathy Baik
Molly Bolthouse
Alex Brouwer
Hannah Clark
Cooper Dowd
Caitlin Gaines
Brenna Khaw
Kyle Kohner
Amelia Mowry
Eliana Park

videographers

Macie Cummings
Justin Johnson

designers

Kathy Baik
Alex Brouwer
Macie Cummings
Caitlin Gaines

advisors

Olivia Blinn
Preethi Aloka Daniel
Alicia Dewey
Michael Kitada
Michael Longinow
Michal Muelenberg
Jamie Sanchez
Tamara Welter

CPSIA information can be obtained
at www.ICGtesting.com
Printed in the USA
LVHW020011240419
615299LV00002BA/10/P